W9-ARV-699

DEGAS

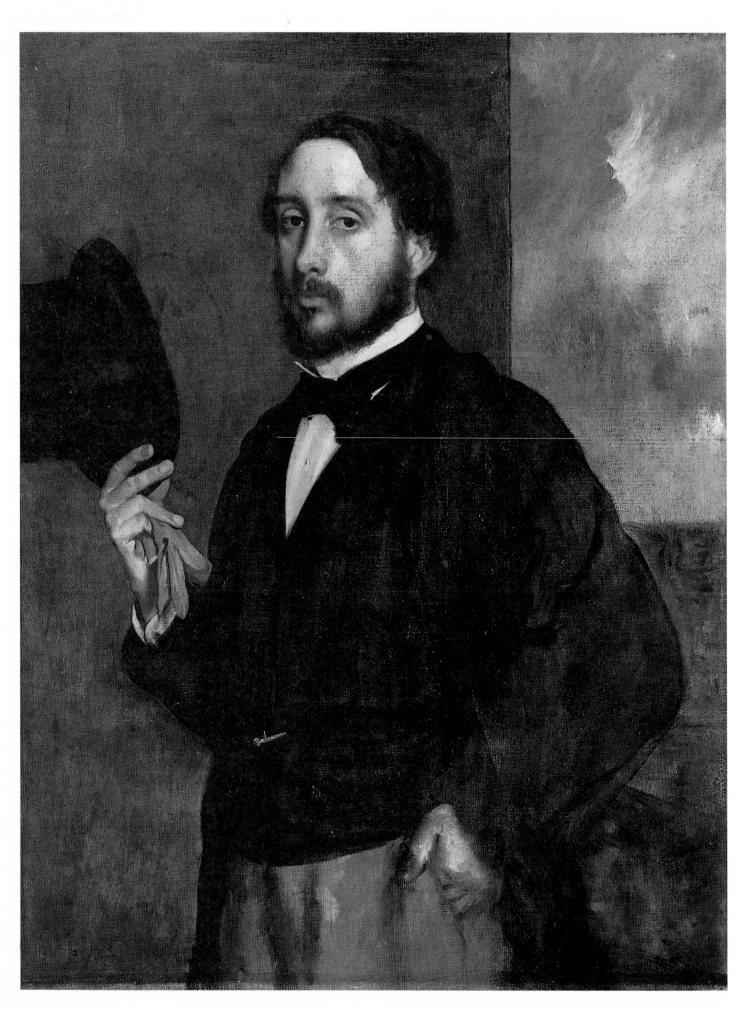

SELF-PORTRAIT. *1862. Oil on canvas, 36¼″ × 27⅛″. Calouste Gulbenkian Foundation, Lisbon*

EDGAR · HILAIRE · GERMAIN

DEGAS

TEXT BY

DANIEL CATTON RICH

———

HARRY N. ABRAMS, INC., *Publishers*, NEW YORK

ISBN 0-8109-0829-8
Library of Congress Catalog Card Number: 84-71110

Published in 1985 by Harry N. Abrams, Incorporated, New York.
Also published in a leatherbound edition for The Easton Press,
Norwalk, Connecticut. All rights reserved.
This is a concise edition of Daniel Catton Rich's *Degas*,
originally published in 1951.
No part of the contents of this book may be reproduced
without the written permission of the publisher.

Printed and bound in Japan

CONTENTS

DEGAS

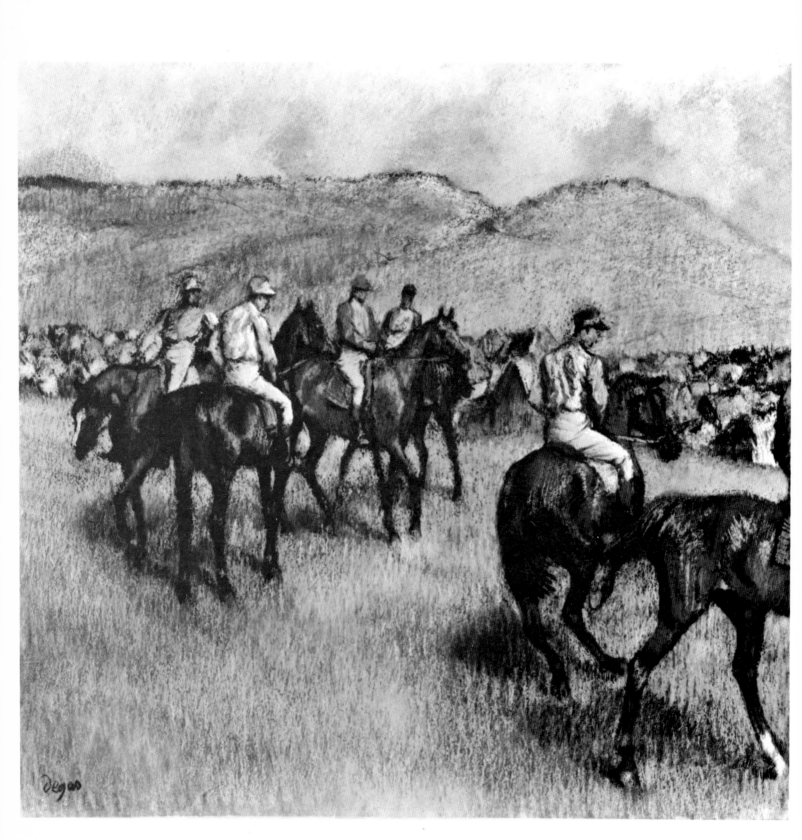

BEFORE THE RACE (pastel, 1876-78). *Private Collection*

ONLY IN THE LAST FIFTY YEARS has Degas' art become publicly visible. When he died in 1917 very few of his pictures, and those chiefly of ballet dancers, hung on museum walls. A part of his enormous output was hidden away in the homes of collectors, while the bulk of his paintings, pastels, prints, and sculpture was stacked or piled up in Degas' dusty, inaccessible studio. Possession of his own early work had grown to be a mania. For years he had refused to exhibit; he hated to sell even the slightest drawing. With his door locked against the world, the aging artist went on working, now and then finding an idea in a carefully guarded sketch or suddenly deciding to scrape out and repaint a passage in some canvas half a century old. Art dealers and critics (Degas had a special loathing for both) were turned away angrily. Words, he said, had nothing to do with art, and his studio was sacred. Was it to be polluted by commerce? Only a few intimates penetrated into the dim room where lay cluttered the art of a lifetime.

Why did he go on working? Because one must; work provided the consolation of old age. One worked, also, for a few friends, for a few unknown people who might understand, and for a handful of the great dead, the old masters whom Degas worshiped and whom, under the strain of modern life and the conflicts of his personality, he had dared to rival. At the same time he knew that the world would be surprised when it learned someday how hard he had labored.

In this Degas was right. When, after his death, hundreds of drawings and paintings poured out of his studio and were put up at auction in Paris in four enormous sales; when the dried wax and broken clay of his sculptures were reverently picked up, placed together, and cast in bronze, Degas was finally revealed at full length as one of the great artists of his century, a draftsman of extraordinary resource and vitality, a portrait painter among the most subtle France has produced, and a haunting colorist who at the very end of his life achieved a powerful, truly expressive style.

That his artistic abilities emerged at all is some-

what surprising, for the environment seemed definitely hostile, if not fatal. Edgar-Hilaire-Germain De Gas was born in Paris in 1834 of wealthy upper-class parents into the very midst of old-fashioned conservatism, good taste, and prejudice. It was only after he became a full-fledged artist that he gave up the more aristocratic spelling of his name in two words and signed himself simply, "Degas." His father, Auguste, was a most respectable banker in an age of family banking. Auguste De Gas had been born in Naples of a French refugee father and an Italian mother, and had married a Creole from New Orleans. These strains meeting in Edgar helped to warm the typical coldness and diminish the reserve of the French bourgeois mind. His father, moreover, was an

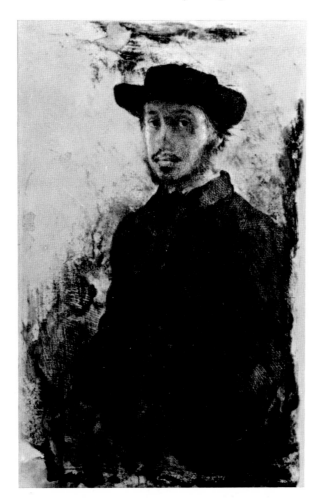

SELF-PORTRAIT (etching, 1855)
The Art Institute of Chicago

enthusiast of music; an amateur organist, he played every week in a Paris church.

As the eldest son, Edgar was clearly marked for the family business. Dutifully he passed through a conventional *lycée*, but the only "first" he got was in drawing. In notebooks, along with worthy maxims and lists of reading to improve the mind, he incessantly sketched dream heads and figures in profile. He had a recurrent dream of his own: to be an artist.

After several years he succeeded in convincing his father that he was right. He enrolled in the studio of Louis Lamothe, a former pupil of Ingres. During the fifties, Paris was noisy with rival leaders and loyalties. Most powerful was Ingres, the dictator of Neo-Classical painting who drew superbly and made draftsmanship the core of his art. At the opposite pole was the romantic Delacroix, an inspirationalist who stressed emotional color above form, but who had revived to a brilliant degree the sweeping movements of the Baroque. There were realists drawn to Courbet, the robust and tendentious peasant from Ornans who painted with a surge of strength new to nineteenth-century art. There were the sincere, gifted, and often tiresome Barbizon painters who were mingling Dutch and English minuteness with the new spirit of scientific description. One of them was a master whom Degas could admire—Corot—boring in his official Arcadian style but exquisite the moment his emotions were freshly touched.

Significantly Degas lined up with the *Ingristes*. They were the most respectable, the closest to the upper-class world in which he moved.

What did he learn from Lamothe? The whole academic procedure of the times: how to assemble a large historical composition from the first pencil drawing of the model to the last smooth brush stroke which must not conceal the lapidary contour of each separate figure. These were still the precepts of David, the founder of the Neo-Classical school at the time of the French Revolution; but all revolutionary ardor was missing from Lamothe's thin instructions. If Degas had not rushed to the Louvre to copy Italian masters of the

STUDY FOR PORTRAIT OF DURANTY (charcoal and white chalk, 1879). *The Metropolitan Museum of Art, New York*

fifteenth century, if he had not pored over Mantegna, Dürer, and Rembrandt in the Print Room, he might have been ruined. But he could unlearn in the afternoon what he had been taught in the morning.

He was fortunate, first at twenty and then on many later occasions, to travel to Italy. In Paris he had spent only a brief time at the heavily official Ecole des Beaux-Arts; in Rome he avoided enrolling altogether in the French Academy. Instead he traveled in a delirium of happiness through Italy itself, opening his eyes wide to art. The entries in his diary show a sensitive, highly impressionable, and intelligent young man; he is not embarrassed to find tears in his eyes at Assisi, to express amazed enthusiasm for the Signorellis at Orvieto. He constantly studied, sketched, copied; and much of his success in later portraits came from this understanding of Italian masters of the fifteenth and sixteenth centuries. Not that he

was to pose his figures à la Renaissance; he imported none of that cumbersome period furniture which weighs down, for example, many works by the Pre-Raphaelites. The secret, he realized, was to follow the advice of the masters without imitating them; from their principles to produce something entirely different. Simplicity of silhouette and purity of line were to be learned from the early *quattrocento*; dignity of form, perfection of modeling from Pontormo and Andrea del Sarto. Humanity everywhere but never out of control; the mystery of a Leonardo figure was not to be found in its repose but in its very inexpressiveness. Subdued color harmonies came to enchant him. He sought, rather too often, the patina of color instead of color itself, the cloudy gold of an ancient varnish, the pale, dimming blue of some Umbrian wall. But unlike Whistler who tried to hurry the judgment of posterity by giving his canvas the artificial bloom of the centu-

ries, Degas never overstressed this element. He never overstressed anything and it is typical of his Italian travels that he stopped this side of Venice.

From the first he had had the idea of becoming what the French call " a painter of history." That meant following David, Ingres, and his teachers, and constructing some " big contraption " with an ancient or Biblical subject. He tried several of these

YOUNG WOMAN IN STREET DRESS (essence, 1872)
The Fogg Art Museum, Harvard University,
Cambridge, Mass. (Meta and Paul J. Sachs Collection)

vast compositions but in spite of admirable elements and high intentions they refused to function.

Degas seems to have realized, unconsciously, that historical painting in the Paris of Napoleon III was doomed. But when it came to portraits, all his sharp observation and knowledge of past design sprang to his aid. The series of little self-portraits in which he unflatteringly caught his own mobile, somewhat melancholy features, or the searching studies he made of his family, show Degas unhampered by recipes and rules. They reveal a new concept of the portrait in which naturalness and intimacy are stressed over studio formality.

The ambitious canvas of the Bellelli family (page 53), over five years in the making, announces in no uncertain terms Degas' qualities as a portrait painter. He is first and foremost a psychologist, trying to capture and fix the interior life of his sitters. His portraits are carefully built up from a series of preliminary sketches and drawings, never painted straight from nature. This was the method of the masters, a method so strongly recommended by Degas that he once told a student to pose the model on the ground floor of the studio and do his painting on the second. Forms and expressions must evolve in the mind, undistracted by too many quick impressions from life. This explains why he documented so exhaustively; for one portrait alone, that of Mme. Burtin, he filled an entire notebook with studies of her hands, trying to arrive at the just solution.

In the Bellelli portrait the design is deliberately traditional; the Baroness and her daughters are fitted somewhat relentlessly into a pattern of straight lines and right angles inherited from Holbein and the early Florentines. But there is also a new casualness at work. Critics have pointed out that Ingres would have been shocked by Julie Bellelli's pose, with one leg comfortably tucked under her dress. In later portraits this element of naturalness is much expanded. Degas' acute eye seizes with snapshot alacrity some peculiar quirk, some unusual gesture or movement, which reveals the inner character of his model. Along with such

penetration goes a desire on the artist's part to give a more general meaning to the faces and forms he was portraying. For this reason, Degas' portrait drawings are often more immediate, more lively and full of grace and discreet energy than the completed oils.

It was Paul Jamot, I believe, who first pointed out the sense of interior drama which takes place in Degas' groups. It was not enough for the artist to characterize each sitter; he was profoundly interested in the play of one personality upon another. In the Bellelli family there is a hidden, but none the less apparent, feeling of tension between the standing mother and daughters on the left, and the seated father on the right. There is no story; only a situation from which Degas has immobilized a moment. Everything in the careful setting of the room with its beautifully painted details and clear, gray light contributes to this mood.

Even in portraits where the artist has painted only two persons he is quick to exploit contrasts. He portrays his aged father sunk in a reverie, listening, as the guitarist Pagans sings and plays (page 61), and there are here further contrasts of pose, generation, and type. As Degas broadened his understanding, his power to catch the fleeting pose and transient expression grew. Jamot has shown how certain of his sitters seem to have just alighted on chair or sofa; they have been surprised in a moment between other moments and will quickly move out of the artist's range. Always lines of psychological force play delicately back and forth between them.

These people do not seem to be posing in the studio of a painter; they are discovered in their own homes and Degas is at pains to suggest the atmosphere of familiar things which surround them. In the strong portrait of Diego Martelli (page 97), the Italian engraver is shown in his stu-

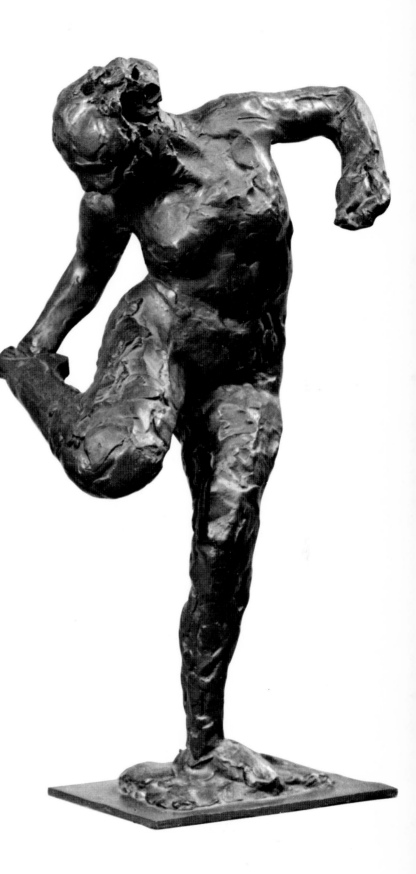

DANCER LOOKING AT THE SOLE OF HER FOOT (bronze, 1900?)
The Metropolitan Museum of Art, New York
(The H.O. Havemeyer Collection.
Bequest of Mrs. H.O. Havemeyer, 1929)

13

dio with proofs and portfolios scattered round him; Mary Cassatt is glimpsed at the Louvre and seen only from the back, leaning casually on her umbrella and staring at a picture. All of these people are friends or members of his family. Degas never did a commissioned portrait. Sympathy between artist and sitter was the first requirement of his art. From such a rapport derives his tenderness, his exquisite insight, not unmixed with a

WOMAN ON HORSEBACK (pencil, 1860-65)
The Louvre, Paris

fastidious irony when he detected a trait of character or a tic of behavior which pointed up the conception.

Over the sitters of his choice Degas exercised the rights of a tyrant. He broke off in the middle of one portrait when the sitter, Mme. Dietz Monnin, began making suggestions; he had started something in his own manner only to find himself transforming it into hers. When a beautiful woman wanted to pose for him he told her bluntly: " Yes, I'd like to do a portrait of you, but I'd make you put on a cap and apron like some little maidservant."

There is another element in these portraits. They speak undeniably for a social class. The Second Empire marked the triumph of the bourgeoisie as the real rulers of France. With his wealth and noble Italian connections, Degas sought out distinction and aristocratic tone. During his early days the artist was often seen in the best houses of Paris. He caught the line, the elegance of the period, painting it with a distinguished touch. So preoccupied had he become with this social milieu that Duranty, the apostle of the new realism in literature and art, said half-jokingly that Degas was " on the way to becoming the painter of high life."

In these pictures there is little technical innovation; Degas preferred the smooth finish and tonal harmonies of tradition, accented here and there by somewhat precious touches of color or varied by a passage of broader brushwork lending relief to a face or movement to a background. It is significant that after 1870 he painted fewer and fewer portraits. The war and the Commune that followed disturbed Degas profoundly. When he returned to his studio after six months' service in the defense of Paris, he found that the society he loved was breaking apart. He began to feel out of touch with his times and to look round him for new subjects where vivacity and the flow of life could be better expressed than in the portrait. These he found in the opera and the dance.

He went to the Opera House touched by a new spirit in French art which a group of young painters, among them Manet, Renoir, Bazille, Monet, and Pissarro, were expounding. Come out of the

studio, they proposed, look at the moving spectacle of life round you; paint the light, the atmosphere, the people of Paris, put down what your eye sees. The Greeks and Romans are dead; long live the charms of modern life!

Degas was more than half-persuaded. As he sat nightly with his friends at a table in the Café Guerbois and listened to the brilliant talk of Manet, the leader of the group, he began to see new possibilities round him. Occasionally he threw in a searching remark; his companions came to appreciate his intelligence and fear his wit. When Whistler, dressed in bohemian style, joined them, Degas looked him up and down and remarked acidly, " You behave, my friend, as though you had no talent."

There were things said at the Café Guerbois to which he could never agree. These centered around nature. Monet and Pissarro preached surrender to nature. This meant forgetting the

THREE DANCERS (charcoal and pastel, 1879). *Private Collection*

masters and depending only on what your eye revealed. For Degas there was more to art than that; painting was an affair of intelligence. The mind seized sensations from nature but controlled and refined them. One built a work of art *mentally*; through patient observation and style one carried

MISS CASSATT AT THE LOUVRE (pastel, 1880)
Collection Henry P. McIlhenny, Philadelphia

it out. Let there be no abandonment to uncritical emotion. It was infinitely more worthwhile, he insisted, to learn to draw after Holbein.

All the same, the idea of surprising new effects from everyday life was sound. Years before, he

had set down in one of his notebooks a series of projects where houses, streets, people, and even still life, were to be studied from new and arresting angles. He had imagined a studio where the model stood still and the artist moved above and below and around her, catching unfamiliar aspects of the familiar. He had planned a whole series of the arms and legs of dancers in motion.

Hadn't he been the first to explore the action of race horses at the fashionable tracks near Paris where gentlemen riders, brilliant in their silk coats, rode elegant highbred animals? In their quick, turning silhouettes, Degas had discovered a new liveliness in drawing and it was with the same desire for the flow and sudden stop of movement that he now made his way to the dancers of the Opera.

He began rather cautiously. He felt he had to study every step, every position in the formal ballet. One can follow his progress from the classroom where he painted his first pictures, to the rehearsals on the stage, to moments from actual productions, and on to a final liberation where, improvising and inventing, he created from this shifting material a new fantasy of color, unexpected space, and light. When Edmond de Goncourt called on Degas in 1874 he wrote: " The painter shows you his pictures, from time to time adding to his explanation by mimicking a choreographic development, by imitating, in the language of the dancers, one of their *arabesques*, and it is really very amusing to see him, his arms curved, mixing with the dancing master's aesthetics the aesthetics of the artist."

Degas' first little canvas of the ballet, the *Dance Foyer at the Opera* (page 67), is almost conventional in its precise drawing, pale color, and traditional perspective. There is little motion. But three or four years later, in another canvas titled *The Dancing Class* (page 83), the painter arranged the room on a diagonal, tilting up the floor and starting a play of movement and countermovement among his groups.

In the period between these two pictures Degas had taken a most uncharacteristic trip to America. Visiting New Orleans in 1873 to see his brothers,

he lingered there for many months, producing a few family portraits under far from favorable conditions with his relatives hanging over his shoulder or refusing to pose as seriously as he wished. He returned with one ambitious canvas, the *Cotton Market, New Orleans* (page 71). Here, under the hard American light he portrayed the members of his family in a business office. Everything is studied to the point of dryness but the final effect is not photographic. Degas has organized all his detail into a firm design, setting his figures into deep space and producing an equilibrium that no camera could achieve.

Degas came back to France with a strong conviction that he would settle down in Paris for the rest of his life: one Parisian laundry girl with bare arms was worth all the picturesque people in far away places of the world. " I want nothing but my own little corner," he wrote to a fellow painter, " where I shall dig assiduously. Art does not expand; it repeats itself. And if you want comparisons at all costs, I may tell you that in order to produce good fruit one must line up on an espalier. One remains thus all one's life, mouth open so as to assimilate what is happening, what is around one and alive."

About this time he thought of marrying. He dreamed of an ordered existence, a good wife, children, a happy old age. But Degas had a hard, aloof character. His irony which turned readily to sarcasm, a sense of perfection which drove him on to constant experiment, perhaps at base a fear of allegiance to anything except his art, kept him a bachelor all his life. Now money worries beset him. His father's death had uncovered a huge debt in the family bank. Edgar and his sister and brothers honorably paid back the losses. He began to live strictly, even stingily. For the first time in his life he tried to make a living by selling his pictures.

He threw himself into helping organize the first showing of those painters soon to be named, by an unfriendly critic, the Impressionists. Many of his old friends from the Café Guerbois were among them: Monet, Renoir, Pissarro, Sisley, and Cézanne. Joined by new recruits and converts, their first exhibition of 1874, at the former studio of the

photographer, Nadar, became a *succès de scandale.* When the group showed again two years later, Albert Wolff, intemperate reviewer of the *Figaro,* greeted Degas' entry of twenty-two works in this way: " Try, indeed, to make M. Degas see reason; tell him that in art there are certain qualities called

THREE NUDE DANCERS (charcoal, 1892-95)
The Art Institute of Chicago

drawing, color, execution, control and he will laugh in your face and treat you as a reactionary."

Though exhibiting with Impressionists, Degas disapproved of the label. He was clearly not one

of them. Painting out-of-doors he made fun of: gendarmes, he remarked, should shoot down these rows of easels which cluttered up the countryside; and he once turned up his coat collar in protest before a particularly misty painting of a landscape. But he was undeniably influenced by these contacts. Impressionism helped free him from what Cézanne called "the art of the museums." He began to seek new and daring effects of light, the footlights and shadows of the theater, the steamy radiance of rooms where laundresses ironed and yawned over their labors, the glow of gas globes in the night cafés. There is another side to Impressionism besides its reliance on light and color. It created an original manner of drawing—rapid, almost stenographic in effect. Artists tried to

STUDY FOR A PORTRAIT OF EDOUARD MANET
(lead pencil, 1865-70)
The Metropolitan Museum of Art, New York
(*Rogers Fund, 1918*)

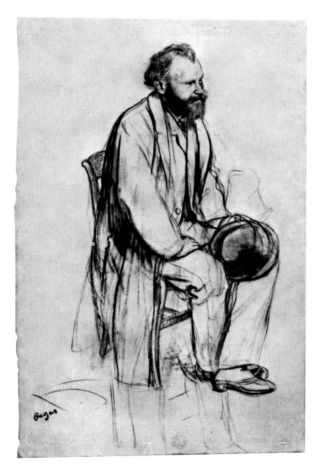

forget what they knew about the structure of the body, and to convey the passing blur and broken line of figures in action. Though Degas could never forget anatomy, he responded to this freer shorthand.

As he worked on he began to replace much of his painting in oil by pastel. Pastel satisfied his desire for brilliant, more vaporous color and allowed him to draw and paint at the same time. " I am a colorist in line," he explained to a friend. Degas had an increasing dislike of shiny pigments; he soaked the oil out of his paint and put it on in thin, flat washes. He held his pastel sticks over steam to soften them and evolved a complicated mixture of pastel and gouache. He would first paint in gouache or tempera and then build up new accents and new details on top in pastel. This meant working on paper, which he preferred. When he wanted to change the shape of a picture he could cut off an inch or two, or join on a new patch and paint over the whole. He was becoming daily more conscious of the exact placement of his design within the frame and he was constantly exploring new approaches to perspective.

Japanese art, all of a sudden the rage of Paris, further liberated him. Where many painters simply snatched fans and kimonos and dressed their models in Oriental garb, Degas probed deeply into the principles of this strange art. The Japanese artist contradicted the whole Western idea of perspective. Renaissance science had decided to represent lines mathematically converging toward a center which was set back in a frame. The Japanese, instead, looked down on their subjects from an altitude. Action started at some point in the foreground, zigzagging in lines and diagonals out of the picture until pulled back by a high horizon.

Many a Degas dancer is drawn with one foot placed angularly in front of the other, almost touching the frame, while from this spot, diagonal movements, like the opening of a fan, spread outwards and upwards (page 101). Especially in his ballet pictures, Degas used the abrupt cutting of figures, the overlapping of one form by another, the exaggerated tilting foreground, the diminished

background—all the repertory of Oriental devices found in the prints and scrolls which were then enchanting Paris. His developed art is unthinkable without Japanese art, and with Degas' adaptation a new conception of space enters European painting. The frame no longer "frames" in the traditional sense. It is like the finder on a camera which rests momentarily here or there, hunting out some particularly striking slice of life. Paintings like *Absinthe* (page 85) and *Ballerina and Lady with a Fan* (page 111) show how Degas used Japanese elements but naturalized them. He had the ability to take the most bizarre arrangement and clothe it with an air of realism.

A mechanical process confirmed the un-mechanical Japanese. The camera, invented a few decades earlier as a new medium for artistic purposes, fascinated Degas. At first he had observed how a sensitive plate revealed the momentary aspect of a person. Now it presented new angles of vision,

caught an image and cut it. Focus was sharp here, blurred there. Degas became an ardent photographer himself, and at times he pushed the new viewpoint in painting so far that it seems to anticipate the candid camera and the motion picture. The *Café Singer* (see page 32) foretells the close-up of our day.

In the best of his ballet pictures Degas went further; he opened up a new world of fantasy. Few of these scenes can be identified with actual productions or the names of reigning ballerinas. They might call him the painter of dancers; didn't they understand, he exclaimed pointedly, that for him the dancer had been only the pretext for painting beautiful fabrics and rendering movement? When Mrs. Havemeyer, the American collector of his work, asked him why he had concentrated on the ballet he answered her seriously: "Because I find there, Madame, the combined movements of the Greeks." The finest of his pastels and oils go

CAFE-CONCERT (pastel, 1876-77). *Corcoran Gallery of Art, Washington* (*W. A. Clark Collection*)

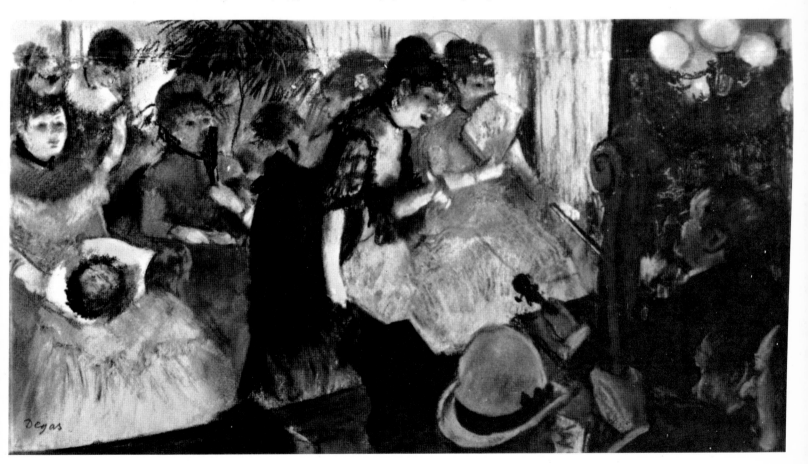

beyond description of dancers on a stage; they suggest qualities of aerial speed, fluid grace, and sudden pauses of controlled vitality.

He also turned out, let us confess it, a great many inferior pictures on the ballet. He gave in too readily to the obvious charms of his subject; the vision flags or becomes overly realistic. The worst of them strikes us today as only pretty variations on stronger ideas. Naturally this was the side of Degas which first attracted the public and for which he is most famous. As he needed money he finished up a number of such pictures for sale. He was the harshest critic of his own work and he seems to have realized their quality. He came

STUDY: " DANCE FOYER AT THE OPERA " (essence, 1872)
Private Collection

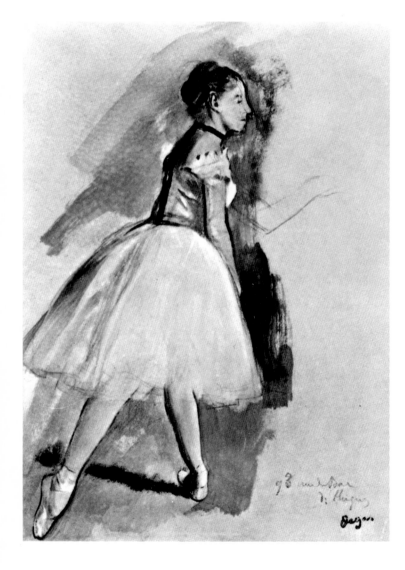

to refer to them somewhat contemptuously as " articles " of merchandise.

Through the successes and failures of his ballet pictures Degas' method grows clear. He did not start from " nature." His first intuition did not come in front of the model but was a mental flash which he turned over in his mind. Only then did he seek to verify it by intense drawing from life. New relationships were now perceived. " Drawing is not form but a way of seeing form," he liked to repeat. He drew not only the same subjects but the same model in nearly the same pose over and over. " Do it again and again," he counseled, " ten times, a hundred times. Nothing in art must seem to be an accident, not even movement." He threw away his drawings; he worked from memory and imagination and as he proceeded a transformation took place. He was freed from the tyranny of nature. With this attempt to capture the perfect form went a strong dissatisfaction with everything he had done. He told Max Liebermann, the German painter, that he wished he were rich enough to buy back all his early work and put his foot through it. He begged back earlier canvases from collectors to " improve " them; sometimes he did; more often they ended in ruin as he found it impossible to graft a new vision on the old. There is a legend that a certain owner of Degas' work in Paris chained his pictures to the wall whenever he heard the painter was coming to see him.

Degas did not forget, in his visits backstage, that he was also the painter of modern life. Many of his best works are not the glamorous moments of the ballet with dancers turning in the spotlight or bowing gracefully to receive bouquets of flowers, but one or two girls seen in their interminable exercises or waiting in the wings, adjusting their bodices or straightening their shoulders. He caught out the meaningful gesture: a dancer stretching her instep, tying her slipper or flopped down in fatigue on a bench. Strain and boredom became major themes. He enjoyed the irony of light airy costumes covering the skinny muscular forms of the Paris " rats," those underfed little girls whose families drove them on to inhuman hours of practice for a few sous a day.

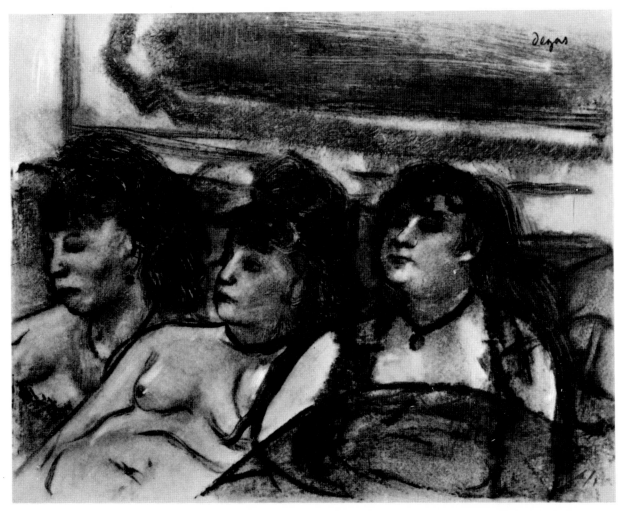

THREE WOMEN (monotype in color, 1879). *Print Cabinet, Rijksmuseum, Amsterdam*

From this material he invented an amazing series of two figure compositions. In the past artists had often avoided the use of two figures alone; they preferred at least three, built up in a pyramid or a group of figures caught in some all-embracing system of curves. Degas became a master of design in two figures. He used it for psychological contrast, as in *Waiting* (page 105), where a weary dancer is paired with a mother in black. He often played one dancer against another, the lines and shape of the first echoing and contradicting the pose of the second. Equilibrium resulted from pushing the figures to one side and balancing fullness with emptiness, or by opposing a front view with a profile. At times he combined multiple impressions of the same figure into a single picture, playing variations on an idea new to art.

This is a free extension of Degas' old skill in the double portrait and even pictures with many figures are brought to life by a tension between two main groups, these groups in themselves breaking down into pairs where the same contrast goes on in diminution. This use of simultaneous contrast he carried into color and technique. Brighter, sharper hues are opposed, the color is frequently broken by spots and dashes in the Impressionist manner, and heavy textures are set against a floating wash or a light powdering of pastel. Line is still the organizing element and Degas at this period remains true to the tradition of drawing. He complained to George Moore that while he had always urged "his colleagues to seek for new combinations along the path of draftsmanship," which he considered a more fruitful field than

21

color, "they wouldn't listen and went the other way."

He found other new combinations in the night life of the city. It was a period of out-of-door cafés with talented entertainers bawling out popular songs and ballads. Degas soaked in ideas from his evening prowls round Paris. Here was a new glitter of modern life to be explored. He set down the forms and the features of the performers satirically: a *chanteuse* with her mouth open

STUDIES OF FOUR JOCKEYS (essence, 1866)
The Art Institute of Chicago
(Mr. and Mrs. Lewis L. Coburn Memorial Collection)

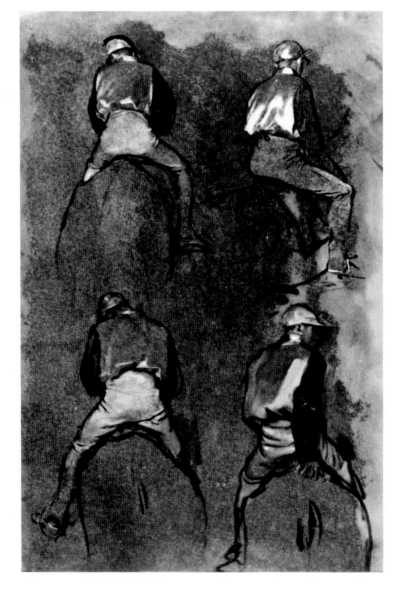

(see page 32), or caught in some half-awkward gesture of pantomime (*The Song of the Dog*, page 81). *Women in Front of a Café*, with its sinister glamour (page 91), he painted in pastel over a monotype, a new kind of print where with ink and color he worked directly on a metal plate and then rolled out one or, at most, two impressions. He entered the *maisons closes* and did a whole series of monotypes dealing with prostitutes, a devastating comment on humanity where the artist's disgust seems to struggle with his visual curiosity (page 21). Long ago he had excelled in etching; his control of line had allowed him to make some telling portraits. He was drawing on a copper plate in the Louvre before an *Infanta* by Velásquez when he first made the acquaintance of Manet. The slightly older painter, already the talk of Paris, stopped before Degas in astonishment. "You're not afraid?" he asked. "I should never dare engrave like that without a preliminary sketch." Degas had only smiled.

Now he took up lithography; all one needs to make a masterpiece is black and white, he insisted. He added aquatint and drypoint to his knowledge of etching, restlessly seeking the perfect medium to fit his idea. With his graphic work alone, he created new effects, new suggestions, helping to make artists aware that vision was more important than standard techniques. At one time he would decide to paint laundresses, at another, he visited the shops of fashionable dressmakers. He was never content with one try at a subject. Degas worked in series, one solution leading to another until at least a few chief works could emerge in which he summarized months—or even years—of patient looking and reconstruction in the studio.

Perhaps the most surprising adventure was into poetry. Well read in the classic and nineteenth-century poets, Degas now struggled with the sonnet—a typically intractable form—studying poetic rules and buying a dictionary of rhymes. He filled a small notebook with phrases, scratching out lines, altering images. At his easel he would repeat a sonnet until he was satisfied with it. Most of his poems dealt with themes he had made his own, jockeys, dancers, and the stage (see page 110),

treated in a terse, original way. One day, meeting Mallarmé, the great Symbolist poet, Degas complained that he was too full of ideas and had difficulty in getting them down. " It is not with ideas one writes," replied Mallarmé gravely, " but with words."

Until about 1886, the year of the final Impressionist exhibit, the artist had concentrated on one chief problem: how to combine the instantaneous vision of Impressionism with the undying principles of Classical art. It was a struggle between eye and mind, and Degas, in spite of an increasing rancor against the world and a seriously dimming eyesight, had almost reconciled the two. He had brought a new mobility into painting, clothing his rhythmic designs with psychological insight. He had attempted to give everything he touched an air of grace and tradition. Through it all he had remained the realist, the sharp commentator on certain phases of Parisian life so that part of him belonged to the age of Flaubert, de Maupassant, and Zola. Another and perhaps more creative part belonged to the world of imagination and fantasy where forms give off their own magic and where instead of a string of dancers moving in a calculated pattern, lines and colors and masses create their own rhythms and overtones of meaning. Did Degas' sudden discouragement at reaching the age of fifty spring from the realization that much of what he had done lay in a somewhat narrow realm? " Everyone has talent at twenty-five," he complained to Walter Sickert, the English artist, " the difficulty is to have it at fifty." Did it all add up to greatness or only to a superb kind of performance? Was it art or merely virtuosity?

Now he knew moments when " a door shuts inside one ... one suppresses everything ... and once all alone finally kills oneself out of disgust. I have made too many plans, here I am blocked, impotent." Earlier it had seemed there would always be enough time. " I stored up all my plans in a cupboard and always carried the key on me. I have lost

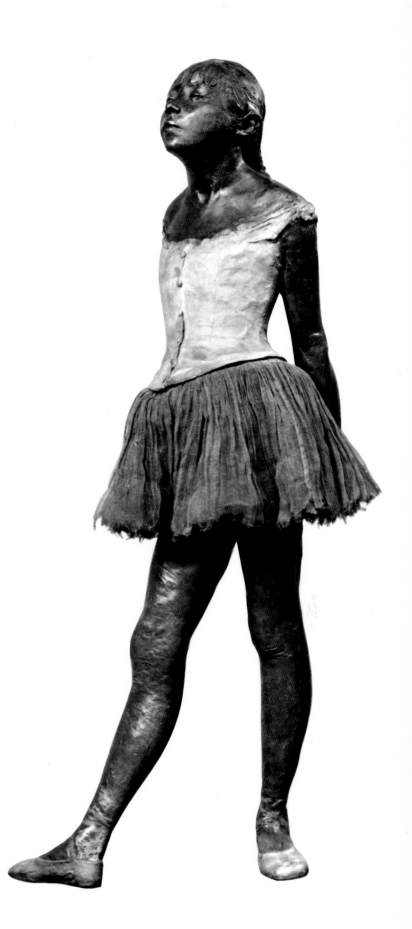

A DANCER AT THE AGE OF FOURTEEN (bronze, 1880)
The Metropolitan Museum of Art, New York

that key ... I am incapable of throwing off the state of coma in which I have fallen. I shall keep busy, as people say who do nothing, and that is all."

He withdrew, in the very center of Paris. Renting a tall house on the rue Victor-Massé in Montmartre, across from the Bal Tabarin (which he never entered), he shut himself away. He abandoned café life and no longer went out to dine except with a few old friends like the Rouarts or the Halévys. Painting became a private life. He hated to leave Paris, though he complained of the heat of summer; and if he did go away to the country, to a great house in Normandy or to the South for a "cure" at some health resort, he was anxious to return. He still had to look at everything; the movement of people and things distracted and even consoled him, if one so unhappy could be consoled at all. Disenchanted as he was, a tree from his window could still interest him; " if the leaves of the trees did not move, how sad the trees would be—and we, too," Degas once observed in a letter to a friend.

He had broken with many of his old comrades. The group of the Impressionists had fallen away. There were quarrels, recriminations. Manet, with whom he had felt a certain class sympathy and undying respect for his abilities as a painter, was dead. Degas had said bitter things about him, telling Manet's sister-in-law, Berthe Morisot, that the artist couldn't put down a single stroke without thinking of the old masters. But at his retrospective exhibition, Degas had been impressed: one had not realized how great an artist Manet had been. He had stopped speaking to Monet and Renoir long before. Even Pissarro, the saint among the Impressionist group, had a most difficult time keeping on good terms with him. Yet Degas gladly contributed to the fund that would save Manet's canvas *Olympia* from migrating to America and put it safe in the Luxembourg. He railed against all honors. When Mallarmé finally persuaded the government to buy one of his pictures and generously came to tell him about it, Degas practically threw him out of his studio. To be famous and unknown, that was his desire. He took long,

rambling walks through the city at evening. Only Zoë, his faithful watchdog of a servant, and the models who came daily to pose, saw much of him.

At the eighth and last showing of the Impressionists in 1886 he had exhibited ten pastels, described in the catalogue as " a series of nudes of women bathing, washing, drying, rubbing down, combing their hair or having it combed." One of the earliest of the series showed a woman just out of her bath, a maid handing her a cup of chocolate (page 107). Degas followed it with scores of single nudes studied in every conceivable attitude, twisting, turning, seen from above, from below, leaping from the tub, standing on one foot, or sprawled on a divan. So fascinated did Degas become with this material that he even had a tin bathtub and washbasins installed in his studio. Realism could go no further. To one of his rare visitors the artist remarked, " The nude has always been represented in poses which presupposed an audience, but these women of mine are honest, simple folk, unconcerned by any other interests than those involved in their physical condition. Here is another, she is washing her feet. It is as though you looked through a keyhole."

Was his idea merely to explore the female figure, surprising it, as he had surprised his dancers, in new audacious attitudes? Was all this recording of rippling muscles and firm flesh an end in itself, a new kind of research into the thousand and one unconscious movements of the human body? No, there was something more, springing from Degas' enigmatic feeling toward women. One side of him adored women; he was in love with all that was charming, frivolous, and feminine in their behavior; he had shown it in a hundred portraits and in his pictures of the ballet. He had even, along with Manet and Renoir, helped to create the very type of Parisienne, small, chic, and vivid, with upturned nose and witty smile. But there was another, less human streak in his character. He liked to reveal woman in her nakedness, stripped of her fripperies. There is something disdainful and more than half cruel in the way he pulls out a tautened leg or twists a torso. Gone is

AT THE MILLINER'S (pastel, 1882). *The Metropolitan Museum of Art, New York*
(H.O. Havemeyer Collection. Bequest of Mrs. H.O. Havemeyer, 1929)

the idea which he once held of opening a window on life. Degas is as firmly shut up with his obsession as was Proust with Albertine. His captive was the model in the studio. To a lady who dared ask him why he always made women so ugly, he replied with studied insolence, " Because, Madame, in general women are ugly." At the same time, in showing some of these studies to Sickert he confessed with a characteristic but disarming candor that perhaps he had treated " *la femme* too much as an animal."

This did not prevent him from turning certain of

these pictures into penetrating works of art. As he sharpened his contrasts of color, adding bright and even shrill patches of violet, orange, and yellow-green, as he strengthened his once delicate line to reveal these bodies under new depths of light which play dramatically, but never sensuously, over them, Degas opened up a world as intentionally strange as his world of the ballet. Suspended movement in *The Morning Bath* (page 121) is stretched almost to the snapping point, and there are drawings where the dislocation of the figure becomes painful. We refuse to identify ourselves

with these tortured poses and wonder what has become of that " calm " which Degas once called a leading element in a work of art. Some of these pastels give off an atmosphere of dense, shut-in rooms; others like *Repose* (page 45) are intensely luminous, the figure flooded with electric blues and greens which intensify, rather than destroy, the rhythm of his drawing.

He dreamed of using all he had discovered in some great composition. He was freshly haunted by the old masters, but these, strangely enough, were no longer the Florentines. It was rather to the Venetians that he turned his thoughts, and often his mind wandered treacherously to Delacroix, the archenemy of Ingres, who had believed that color, not draftsmanship, was the basis of painting. He made Zoë read aloud the journals of Delacroix; he set up palettes as the Romantic painter had recommended. In his sketches he began to try a reconciliation. Could Ingres and Delacroix be connected after all through the use of the arabesque, that allover pattern of line, in which every part of the picture could be caught up as in a net? He dreamed of fusing the form of Ingres' *Turkish Bath* with the pulsating richness of Delacroix' *Women of Algiers*, and all of it, *modernized*, in a painting of peasant women cooling themselves, along with their dog, in a country stream. He planned a large picture of these nude bathers, which would combine the strenuous poses of the studio and weave arms and legs and breasts and thighs into a transcendent whole.

He faltered and gave it up. There are many reasons for its failure. Degas' eyesight had become miserable; he worked with a spot constantly floating before his eyes and on one occasion he cried out before his model and flung himself down on his chair, hands clasped over his face as a sudden attack blacked out his vision. Where were the times when he felt himself strong, when he was full of logic, full of plans? Along with this physical affliction went a corresponding failure of nerve. His mind felt heavy and numb. He could no longer depend on his imagination to cooperate in the making of a masterpiece. The gift of transformation had left him. Part of it he blamed on his epoch, which he

had grown to hate with a deep bitterness. " See what differences time has brought," he said unhappily. " Two centuries ago I would have painted Susannah at the bath. Today, I paint only women in their tubs."

For years Degas had been making sculpture, more or less in secret. He had taken it up early in his career, when he had done an exact little model of a horse for one of his pictures painted during the sixties. In 1881 he had exhibited the statuette of a young dancer of fourteen (page 23), a tensely realistic figure in wax, with face and hair painted, and wearing real clothes and slippers like a doll. Paris was stunned; this mixture of sculpture and painting, tulle and abstraction, upset even the artist's friends. Renoir alone, years later, was to recall it with pleasure and exclaim, " A mouth, a mere hint, but what draftsmanship!"

As his eyesight failed he did more and more sculpture; he could still feel form even when he had to ask a model to tell him the color of a pastel. He repeated in clay or wax the repertory of many well-known poses of jockeys, dancers, and bathers. They are far from being the usual flat sculpture of a painter, their forms exist in space and Degas has managed some way to put their straining poses and daring balances into three dimensions. He had all sorts of trouble with them. Whenever he took up a new medium he shunned expert advice. Stubborn and proud, he insisted on finding his way alone. He employed all kinds of impractical ideas for making sculpture. Months of work would be wasted when a homemade armature gave way and the whole statuette tumbled to the floor, or when the clay cracked beyond repair because he had refused to pay enough for good materials. Over a hundred and fifty pieces by Degas once existed, but only a few had been put in plaster at the time of his death. Many lay in crumbled heaps, unrecoverable, and only seventy-three could be salvaged and made whole.

DANCERS ON THE STAGE (pastel, 1883)
Museum of Fine Arts, Dallas

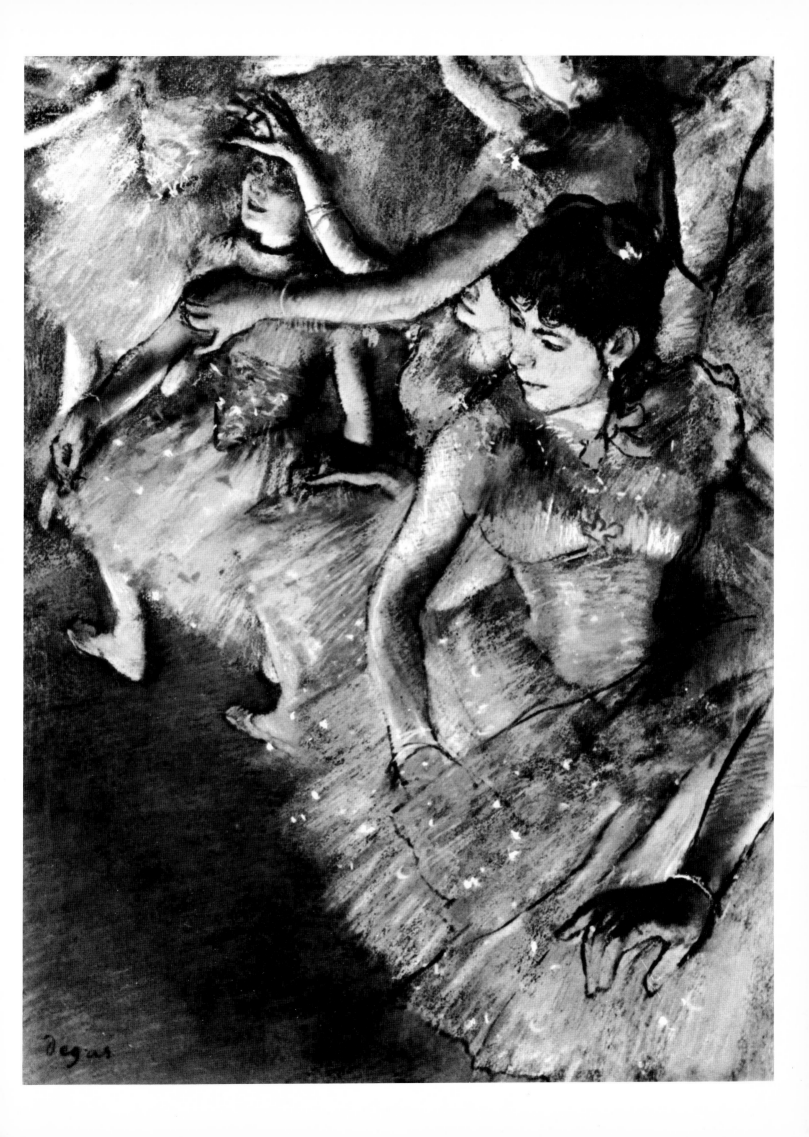

He sublimated his passion for making great works of his own by collecting the works of others. After 1890 the second floor of his house became an art gallery where he assembled a marvelous collection. Degas prided himself on his taste, and when his collection was put on sale after his death there were many surprises. Ingres and Delacroix, his two conflicting idols, were seen in scores of works. He also owned certain eighteenth-century masters, among them Perronneau and Tiepolo. There were many canvases by Corot, Manet, and Cézanne. There were even, surprisingly enough, an El Greco and a Van Gogh. Prints were there by the thousands, beautiful proofs of Daumier and Gavarni. There were paintings by Gauguin, whom he befriended, and sketches by Forain, who was busily turning Degas' inventions into salable illustrations for the weekly magazines; Japanese prints, Oriental rugs (which Degas loved for their unusual range of color), etchings by Whistler. It was a brilliant confession of his enthusiasms and homage to his ancestors in art. Now in the nineties the auction houses found him a frequent visitor; in art galleries he looked less at the work of the young than at possibilities for his own collection. He would pass a hand sensitively over the surface of a canvas: What beautiful flat painting! Nature is smooth and the best painting is always flat—like a door. He even resented the rise in prices of his own work. " If my pictures are going to start selling at such amounts, what is that going to mean for the Delacroix's and the Ingreses! I can't afford them any more," he grumbled. Showing George Moore a faint drawing in red chalk, he said, " Ah, look at it. I bought it only a few days ago; a drawing of a female hand by Ingres; look at those fingernails; see how they are indicated. That's my idea of genius, a man who finds a hand so lovely that he will shut himself up all his life, content to do nothing else but indicate fingernails."

But if he loved and respected Ingres and constantly quoted his maxims, Degas was swinging, in his old age, farther and farther away from the Neo-Classical orbit. He gradually and almost with a feeling of anxiety began to sink his line into simple, glowing masses of color. No longer did he streak and dapple his pastels with small touches. He sketched in broad strokes of pure color and plastered coat after coat of pastel roughly on top. Here a blue neutralized a red; there an orange intensified a rose. Drawing becomes a matter of a few strong accents, and heavy charcoal takes the

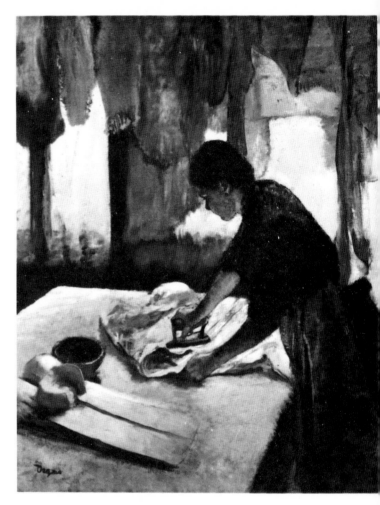

WOMAN IRONING (essence on cardboard, 1882)
Private Collection

place of crayon. The figures grow broader, more solid, and have a sculptural relief, even when seen against scintillant backgrounds (*Woman Drying Herself*, page 125). Roger Fry once said that it took Degas forty years to get over his cleverness; it had taken him nearly fifty to become a painter in the sense of an artist building form through color, rather than through the abstraction of line.

It was almost too late. The best he could do was to take up his old themes of the ballet and remake them. Many are unfinished but their roughness has an obsessive force. Backgrounds have largely disappeared; the figures are thrust forward out of space and grow monumental. Gone are the dancers who earlier moved in a line of grace; these dancers wait heavily in the wings. Their faces have lost their piquancy and become fiercely slashed with harsh strokes, giving them a predatory look. Their poses are angular and jutting, and their heavy costumes are loaded with coruscating color; they have the appearance of strange, fierce birds or tropical butterflies. When action is attempted, as in a remarkable series done from a troop of Russian dancers in Paris, it is exaggeratedly heavy and powerful. Degas was no longer afraid to distort and emphasize. In his last pastels color dies away. Only embers of flaming violets and greens are left, the surface taking on an ashen quality.

A few years before, he had exhibited for the last time. At Durand-Ruel in 1893 he had shown, surprisingly enough, a series of about twenty landscapes, he who had mocked at out-of-door painting. Did he do them in a disciplinary mood, to show Monet and the painters after nature how landscape ought to be composed? His only other attempt in this vein had been in the late sixties, a group of little studies in pastel of effects along the sea coast, reminding one in mood of Boudin and Whistler. By now he had come to have a full-fledged disapproval of those series of landscapes after one subject that Monet had been painting, where each change of light created a new canvas, and where, " like a sundial, one told the hour of the day." He now set himself to paint from memory a number of pictures of mountains, rivers, and valleys, deliberately stylizing them, adding a " certain vagueness, mystery, and fantasy." On the whole they are unsuccessful; they seem blurred and tentative, rather than moving. Degas lacked that command over nature which makes a great landscapist; his best landscapes were still to be found in the backgrounds of some of his jockey subjects, where the merest

indication of outdoors gives a sense of light and distance, keyed to the mood of the horses and riders.

All the time he had been growing more violent, more eccentric. As the Dreyfus Affair split France into two wrangling camps, Degas raised his voice against the Jews. He stopped seeing some of his

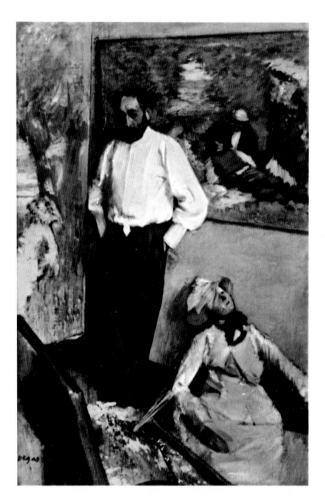

ARTIST IN HIS STUDIO (oil, 1873)
Calouste Gulbenkian Foundation, Lisbon

best friends and even broke at last with Pissarro. More and more he cultivated the legend of " that terrible M. Degas," whose savage remarks and vile temper drove away the public and left him to a lonely and intemperate peace. " If I didn't behave as I did with people," he confessed to Vollard, " I wouldn't have a minute to myself to work," and he was furious when a young

woman, to whom he had revealed his amiable side, began saying everywhere that the world was mistaken in Degas, that he was not " bad," after all. " If you take that away, what will be left? " he cried anxiously.

He paraded his hatred of writers, reformers, politicians, " thinkers," and architects, blaming them indiscriminately for the " impossible " state of civilization. Firmly he turned his back on modern inventions like the telephone and the automobile. He cursed all speed and " progress."

On the other hand, to those he loved, his nieces and nephews, or the few friends who would put up with him, Degas exhibited a charm of manner and a deep tenderness. Behind this terrible façade lived a highly sensitive and emotional man who craved affection, who wrote warm and bantering letters to Rouart and Bartholomé, and who went out of his way to sympathize with their misfortunes. This unhappy mixture he realized in his own character. To an old friend, the unsuccessful painter, De Valernes, Degas wrote a significant letter confessing that if he had been " hard " with him, he had been doubly so with himself. " I was or I seemed to be hard with everyone through a sort of passion for brutality, which came from my uncertainty and my bad humor. I felt myself so badly made, so badly equipped, so weak, whereas it seemed to me that my calculations on art were so right. I brooded against the whole world and against myself. I ask your pardon sincerely, if beneath the pretext of this damned art, I have wounded your very intelligent and fine mind, perhaps even your heart."

He still worked on, as he said, " accomplishing nothing, finishing nothing." On days when his vision was clearer he would mount to his studio and either draw with large, slashing strokes of charcoal or try to complete a piece of his " confounded " sculpture. Much of his final style springs from his near-blindness. He could no longer see to work in the small; he needed to enlarge everything. On pieces of tracing paper over forty inches high, Degas drew vehemently. Gone forever were the delicate contours; his drawing came to resemble, more and more, the heavy springing line

of Daumier. He drew the same outline over and over; at times the charcoal seems to dig deep into the paper and hew out form. At the very end of his life, Degas reaches back of the Classical side of the French tradition, to the powerful strength of Romanesque carvings. With their blunt attack masking the knowledge of a lifetime, these drawings are more akin to capitals in the cathedrals of Chartres or Vézelay than to Poussin or Ingres.

Degas was finished. Wholly blind in one eye, seeing vaguely with the other, he begged only to be " left on his dunghill " to die. Though his pictures, before the first world war, rose sharply in price, he was untouched by such success. At the Rouart sale when Mrs. Havemeyer paid almost ninety thousand dollars for *Dancers at the Bar*, and Degas found himself being congratulated by the press, he roused himself enough to remark, " I'm like the horse that wins the *Grand Prix* and is given a bag of oats."

Another sorrow was to overtake him. His house was sold and he was forced to move to other quarters. Friends found him a new apartment but so saddened was he by this upheaval that he never unpacked the boxes which held his beloved collection. One of his last pictures was a sketch of himself, with a white shaggy beard and sunken eyes. " I look like a dog," he remarked to Paul Valéry.

What did the octogenarian think of as he lay on his narrow iron bedstead, waiting to die? Perhaps his thoughts returned to those long-cherished projects he had once set down in his notebooks and which he had never found time to explore. Did a vast pessimism fill him when he considered his studio filled to overflowing with unfinished work? He had struggled like one possessed. He had come so close to so many new ways of seeing. Did he remember his conservative father who had cautioned him against " overexciting his imagination " and dwelling with " deceptive dreams "; his uncle's comment that he would one day become a great artist if he relied more on " reason "? God knows, he had used his brain; it had been his greatest asset. At least he had never

discovered a single manner and stayed with it; to have done the same thing over and over again would have killed him with boredom years ago. He had always had an exalted idea of what he *might* do, the highest of standards, and a long way to go. In his despair did he repeat to himself what he had often said aloud, that he knew nothing, absolutely nothing, about art?

Or did he finally sink into a comforting oblivion? The few that saw him stumbling blindly through the streets of Paris, an old-fashioned and somewhat unkempt figure—he who had once been elegant—dodging taxis, in constant fear of being run down, remarked on a change in his expression. The black humor which had once creased his features was ironed away. They say that his face took on the pathos and dignity of the old Homer's. In 1917, in the midst of the war, Degas died. He had instructed Forain that he wanted no funeral oration. "If there has to be one, you Forain, get up and say, 'He greatly loved drawing. So do I.' And then go home."

N O T E: Among the many works consulted, P.A. Lemoisne's Degas et son œuvre, *Paris, 1946, must stand first not only for its invaluable text but for the catalogue raisonné by Paul Brame and C.M. de Hauke. Their dating has been largely followed throughout. John Rewald's many important contributions to the study of Impressionism and Degas in particular were greatly drawn upon. Quotations from the Degas Letters are chiefly from the complete English translation, London, 1947, by Marguerite Kay. My knowledge of Degas' debt to Japan is dependent on E. Hahn,* The Influence of the Art of the Far East on Nineteenth-Century French Painters, *a brilliant (and as yet unpublished) Master's Thesis at the University of Chicago, Chicago, 1928.*

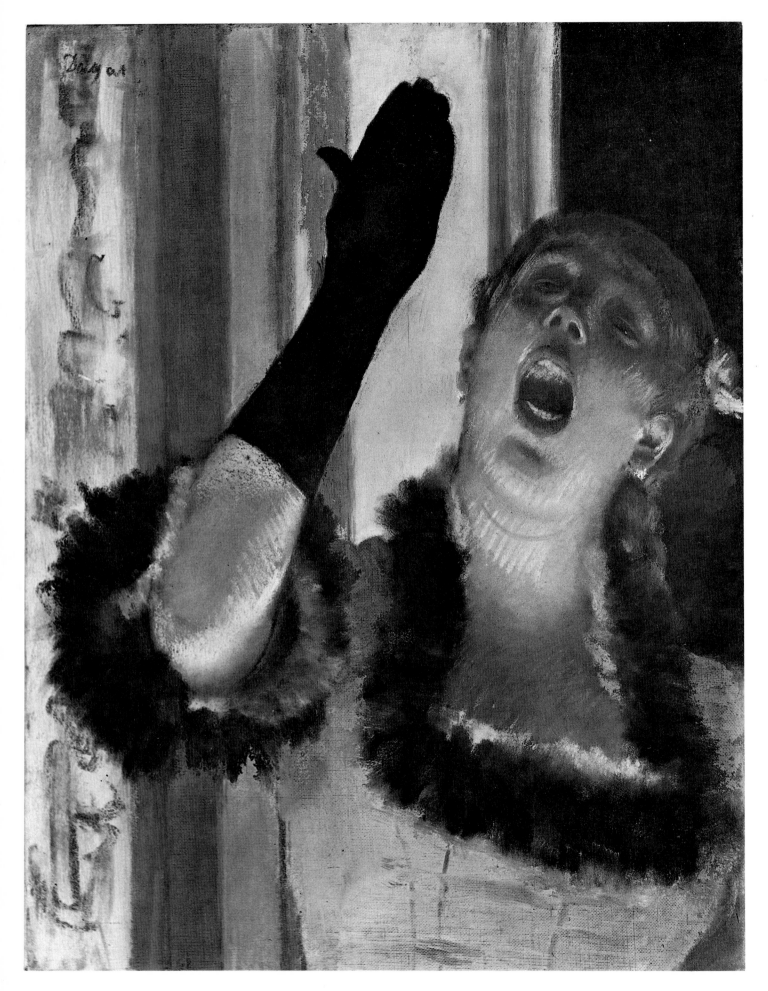

CAFE SINGER (gouache and pastel, 1878). Fogg *Art Museum, Cambridge, Massachusetts*
(Bequest-Collection Maurice Wertheim, Class of 1906)

BLACK AND WHITE PLATES

Painted 1876-1878

TWO LAUNDRESSES

Essence on paper, 18" × 24"

Private Collection

Degas had not been the first nineteenth-century artist to paint laundresses. Daumier had done a series of them in which he curiously ennobled the typical washerwoman of the Paris streets bearing her heavy basket and tugging a child after her. Degas' version is more gracious and more decorative, and typically he has set one figure against the other, enjoying the contrast of poses, the repetition of shapes in the turned heads and the baskets of fresh linen. His outlines are at the same time secure and fluid; and, as often, he has studied the thrust of the figure in action, balancing its load. He has further composed the figures to suggest a moment: one laundress moves to the left, the other to the right as though they were passing and about to move away from one another. The bright color (particularly in the yellow background on the right) thrusts the figures forward, stressing their silhouettes. In a lesser artist the picture would have turned into a mere poster, but so strong is Degas' feeling for the simplified forms and so sensitively does he contrast the modeled heads with the summary treatment of the rest, that the work is remarkably solid in effect. The influence of Oriental art is clearly apparent in the large flat areas and in the contours which remind one of Japanese prints.

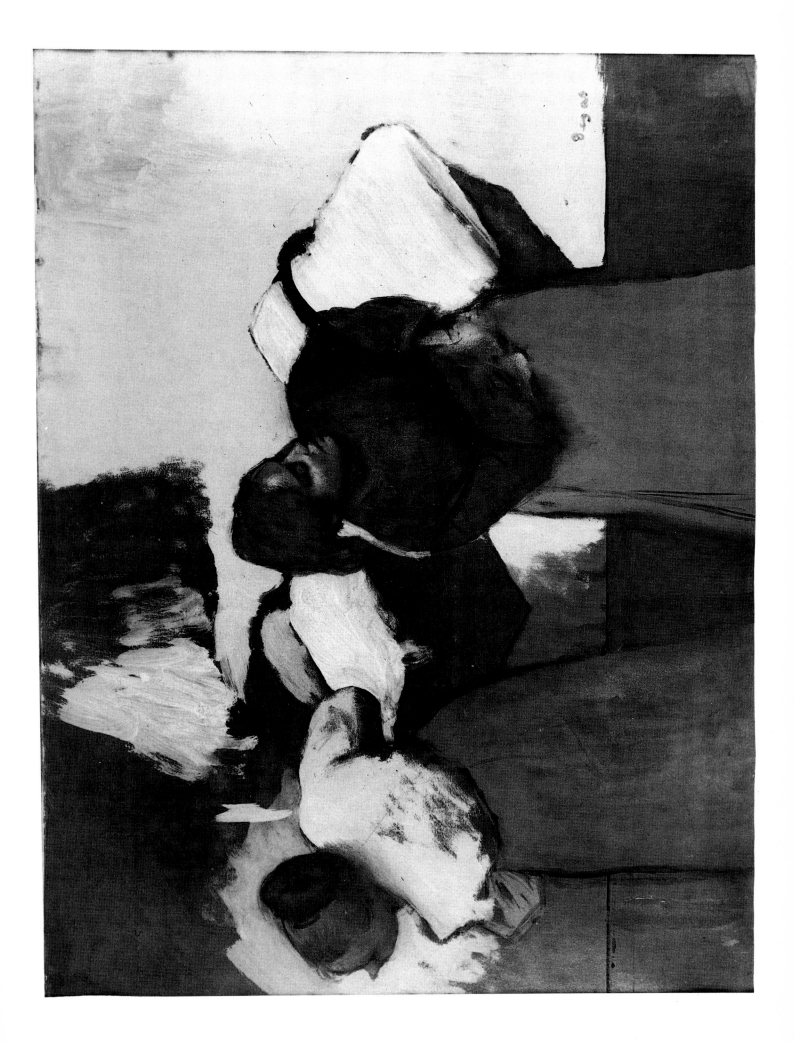

Painted about 1877

THE REHEARSAL

Oil on canvas, 23" × 33"

Glasgow Art Gallery, Scotland (The Burrell Collection)

Degas loved to seize upon different moments of the ballet in rehearsal and combine them into a smoothly composed picture. Here he has welded together such unlikely details as an iron staircase (which is surprisingly cut in such a way that we see only the descending feet of one dancer at the top), files of dancers in movement, the ballet master, and another group of dancers at rest and having their costumes adjusted. The whole takes place in the foyer of the Opera, with soft light gliding in at three windows and touching the various tulles and silks into an attractive color harmony.

Again the artist has connected his apparently isolated groups by a repetition of curved lines, found in the shapes of the ballet skirts, the arc of a dancer's leg, or her extended arm subtly echoed in the lines of the spiral staircase. Against this are set the diagonals of the floor boards, the uprights of the windows, and railings of the stairway, all combined so as to carry movement into the upper right-hand corner, where, characteristically, Degas has put his two strongest notes of red, in the vest of the ballet master and the plaid shawl of the elderly dresser in a black bonnet.

Skillfully, Degas has filled the whole scene with a feeling of air and space, achieved as much through his delicate adjustment of color and tone as through his unusual combination of perspectives. Figures are massed against the light from the windows in the background, their softly cast shadows repeating the pattern of their movement. The weight of the right-hand group is contrasted with the staircase and the dancers in the upper left section. Throughout there is a feeling of lightness, buoyancy, unexpected airiness and charm; we have wandered into the foyer unannounced and have come upon this delightful scene from which the artist has extracted every ounce of visual pleasure.

It is amusing to remember that when this picture was first shown critics found the staircase "ugly." Degas himself studied this part of his picture with passion; after his death a model for just such a spiral staircase was found among the properties of his studio.

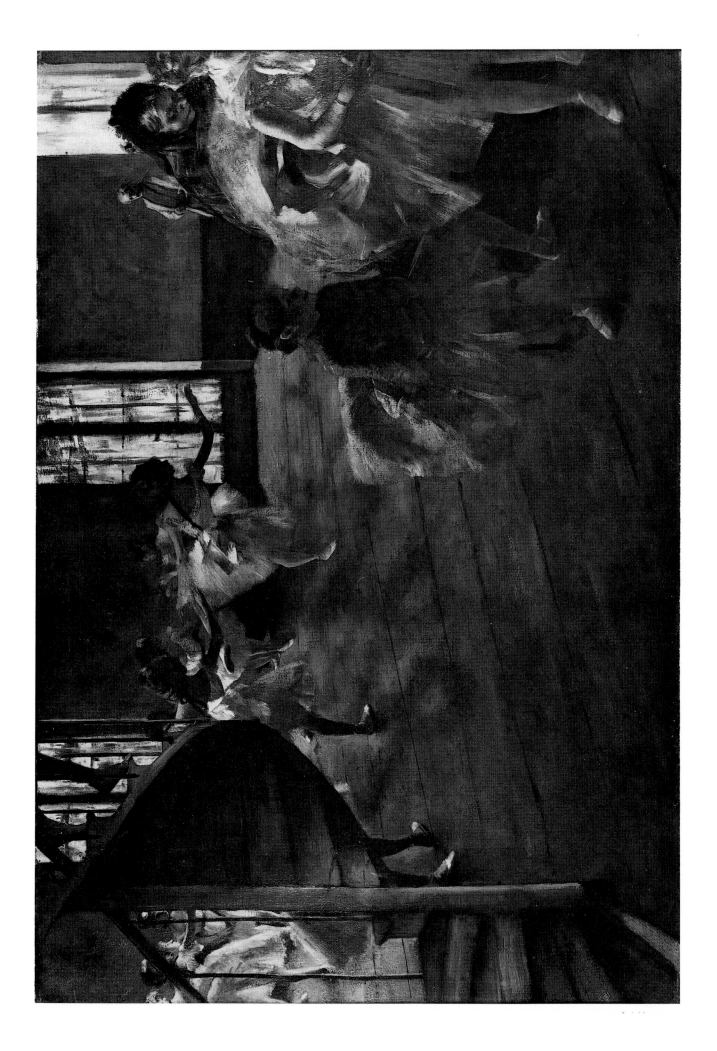

Painted 1880

THE CURTAIN FALLS

Pastel on paper, 21 $^1/_4''$ × 29 $^1/_8''$

Private Collection

Degas attempted nearly every moment in the ballet. This is the finale with the curtain coming down and cutting off the farther dancers, leaving only a glimpse of those in the front row. It is a perfect example of the artist's candid-camera eye and shows how, by catching and holding a moment, he was able to suggest suspended movement and generate in the beholder a desire to complete that movement.

The jostle of brilliant colors, exciting and unusual lighting—all the Impressionist vision of the scene is stabilized by the division of the picture into three unequal horizontal bands. Depth is cultivated by the shadowy recesses of the stage and by the three bows of the violins in the foreground which act as direction lines from the immediate foreground of the orchestra pit. In early theater pictures Degas had emphasized the musicians in the bottom zone, contrasting their dark silhouettes with the luminous area of the stage. Here they are all but eliminated, yet manage to complete the scene and form a base for his composition. The pattern of crossed and jutting arms and legs is contrasted with the shimmering costumes of the ballet dancers. The sketchy strokes of pastel, the feathery surface, and sharp little accents of complementary color add to the picture's animation.

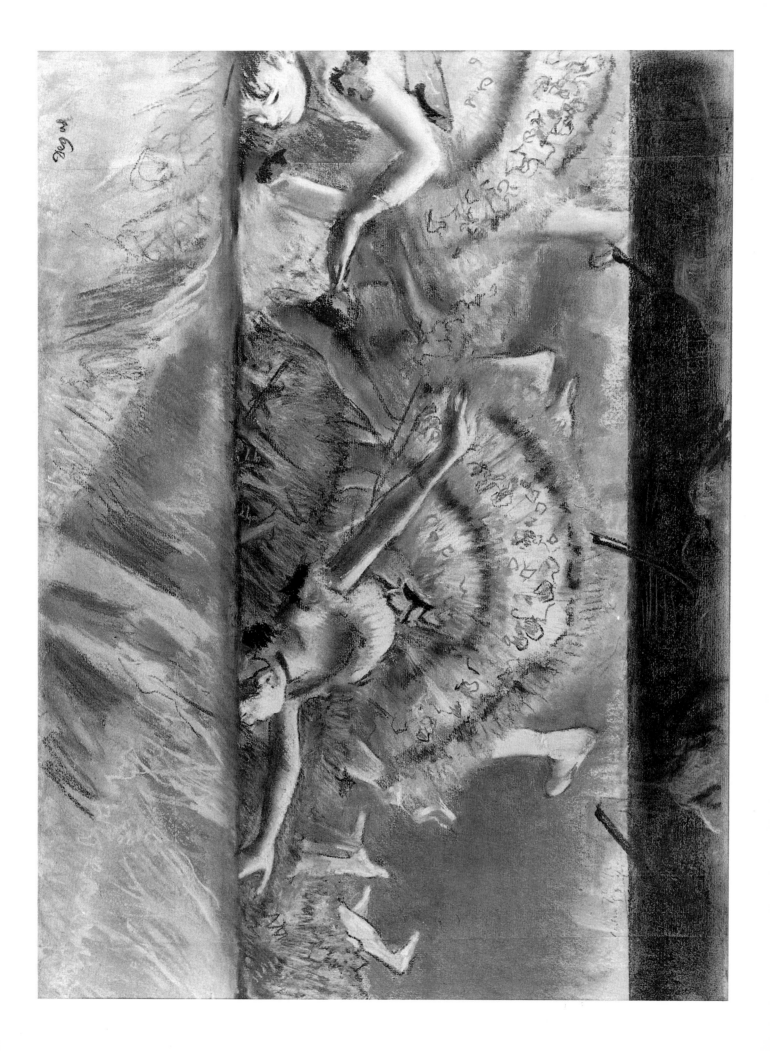

Painted about 1880

DANCER IN A ROSE DRESS

Oil on canvas, 10 ¹/₄″ × 7 ⁷/₈″

Private Collection

There are a number of little paintings by the artist where he has isolated the single figure of a ballet dancer waiting in the wings. This is one of the most delightful and is done in oil, showing how easily Degas passed from pastel to pigment and back again.

Though broadly and swiftly painted, seemingly as an *impression*, the figure is solid in its construction, and Degas has accented the pose of the arms and the profile of the young girl. The scalloped pattern of the scenery is repeated in quirks and contours of the dancer, while the color is unusually deft. Lillian Browse, who has made a special study of Degas and the ballet, says that such little dancers, the so-called " rats " of the Paris Opera, usually came from poor families. After grueling training they were occasionally permitted to perform in their second year; after their third, they were either engaged or dismissed. If they were fortunate enough to hang on, they might expect to be given small roles after eight or nine years of further experience. One of their number who later became a well-known dancer remembered Degas as a man who wore blue-lensed glasses to protect his eyes and was forever stopping the little " rats " backstage to observe or draw them.

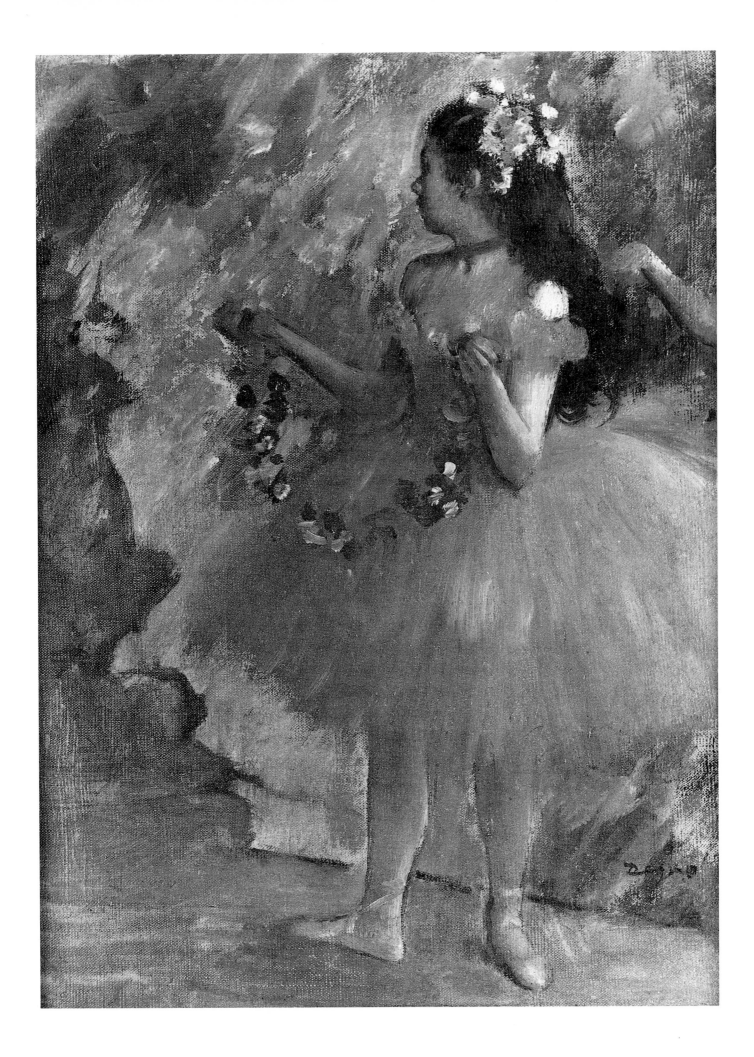

Painted 1885

AFTER THE BATH

Pastel on paper, 25 $^1/_8''$ × 19 $^5/_8''$

Private Collection

Advancing in his pictures of the nude, Degas often found it unnecessary to treat the whole figure. A close-up of this sort could express the whole wonderful solidity of the form, and such works have almost the salience of a fragment of classical sculpture where calm and intensity so permeate the entire conception that we need no more. The artist also has begun to stress and exaggerate certain elements to bring out the action more strongly. Here the foreshortened forearm, the flattened curve of the upper back, the rhythmic line of breast and stomach no longer depict, but express, the theme.

Degas plays the swirling of draperies—some light, some heavy—against the solider form of the figure. He is more and more concerned with a background moving in a different rhythm from the figure, and in forcing an amazing harmony of color: here hues that are sharp and violent in their contrast or tender and delicate in their variations. The medium of pastel is infinitely varied, at places applied to catch the shimmering and transparent effects, in other areas to build solidly by an application of one coat over another. The result is truly classical and modern, a blend of the great past and the immediate, changing, colorful present. Withal, there is little sensuousness of flesh. Degas is too bent on seizing the significant form to be beguiled by more obvious charms or surface appeal.

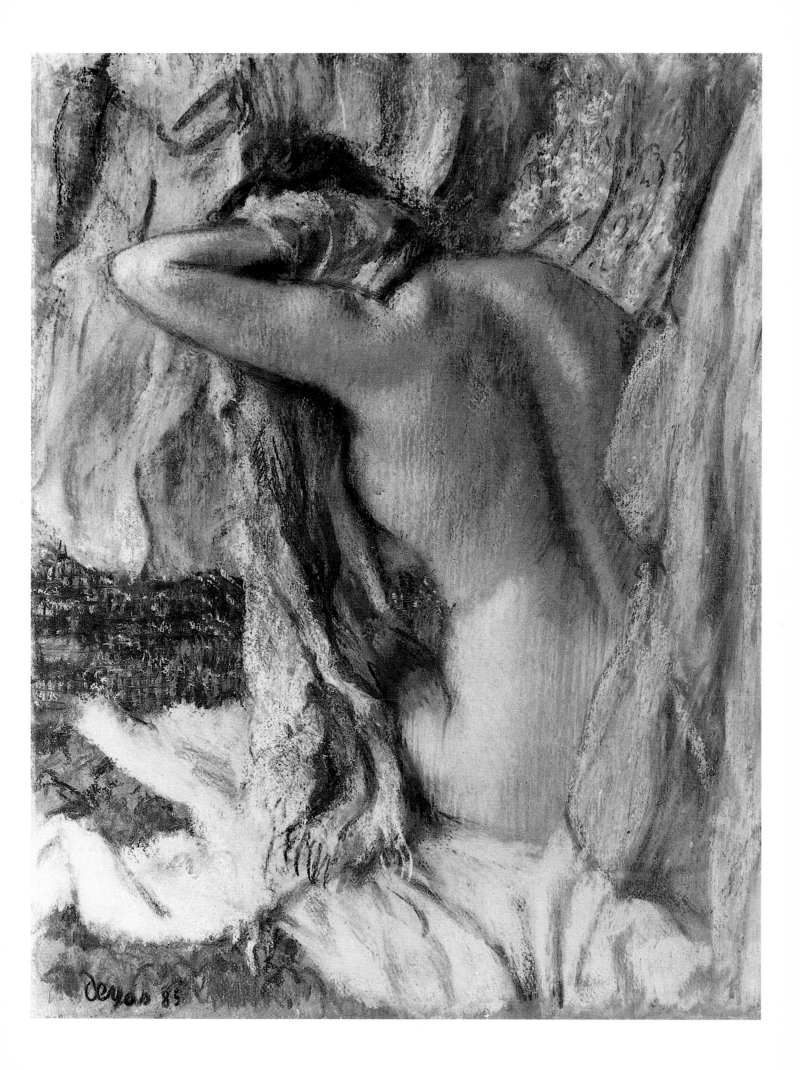

REPOSE

Pastel on paper, 19 ¹/₄″ × 25 ¹/₂″

North Carolina Museum of Art, Raleigh

Not all of Degas' later studies of women were in his favorite theme of the nude body in movement. At other times he cultivated the static, loving to catch a characteristic pose and develop it in several variations of color and palpitating light. Here he renders a composition with great mastery, managing to suggest beneath the pattern of the drapery the almost sculptural force of the figure flung on the bed. He allows himself a greater depth of feeling than in many sketches taken from life where Degas records, rather than creates. The woman is more of an individual than usual; it is as though the aging master, who more and more concentrated on the taut and violently twisted bodies of his models, here sought a profound psychological mood.

Much of the picture's intensity springs from the electric color with which it is carried out. Degas, first in the theater and later in the loneliness of his studio, was one of the first painters to exploit the qualities of artificial light. While the Impressionists tried to catch the dazzle and atmospheric blur of out-of-door nature, Degas concentrated on problems of interior light where he seems, particularly in his early period, to prolong the objective renderings of certain Dutch little masters. Later he loved the harsh glow, the vivid drama of electric light, and here so drenched and saturated is the color that he obtains a strong, original harmony. As usual the rhythmic stroke of the pastel, the vigorous, sensitive outlines and broad modeling convey far more than they actually state.

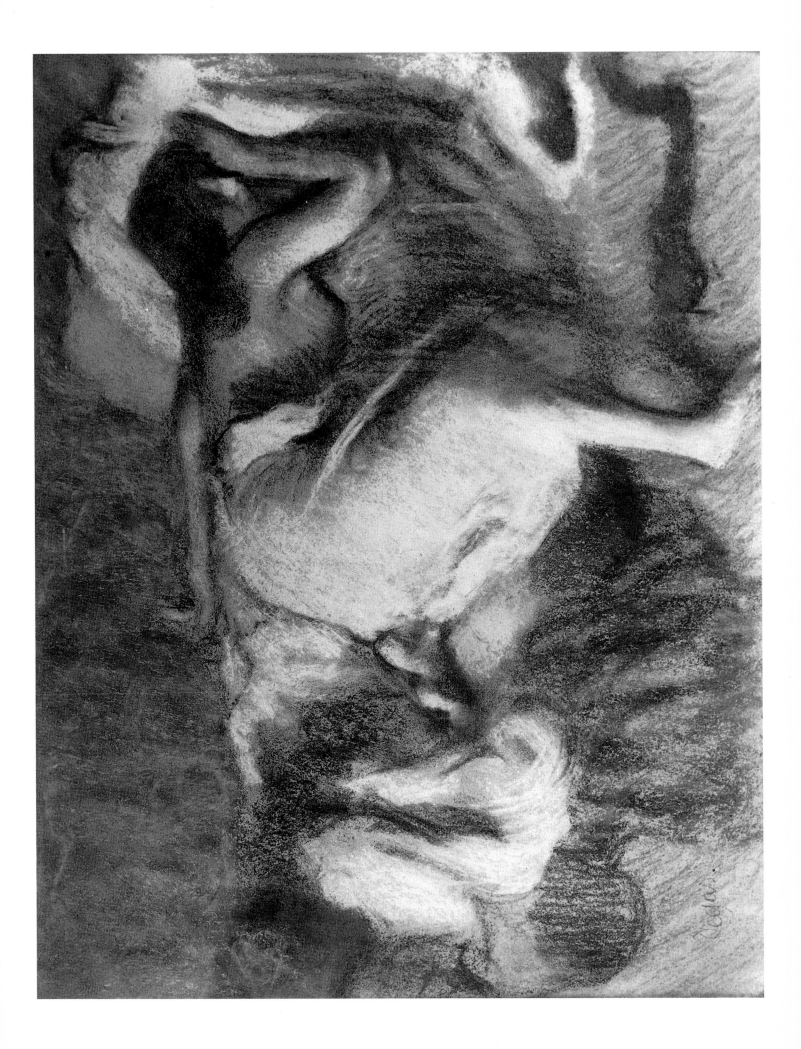

COLORPLATES

Painted about 1857

ACHILLE DE GAS
IN THE UNIFORM OF A CADET

Oil on canvas, 25 $^1/_8$" × 20"

National Gallery of Art, Washington, D.C. (Chester Dale Collection)

Most of Degas' early portraits were of his brothers or sisters or of himself. Members of his family often told how they posed indefatigably for him. In this restrained portrait of his brother Achille, painted in the uniform of a naval cadet, the artist followed in part the tradition of Ingres, his great idol in painting. The somber color scheme, with its reddish-brown background and simple dark silhouette, the careful emphasis on drawing, and the solidly modeled head all point to the Neo-Classical strain in Degas' earlier portraits. And yet there is a directness and modesty already apparent which is the artist's own contribution. In his first portraits Degas had been inclined to imitate poses from Renaissance masters; here the pose is more casual, and Achille looks out with a straightforward gaze which lacks entirely the formality of Ingres. Incisive pencil drawings preceded the painting and in the portrait itself, naturalness, rather than Neo-Classical perfection, was Degas' goal. Undoubtedly he was influenced both by Corot, who painted reticent and sympathetic portraits, and Chassériau, who was warming up Ingres' colder style by an infusion of Romantic feeling.

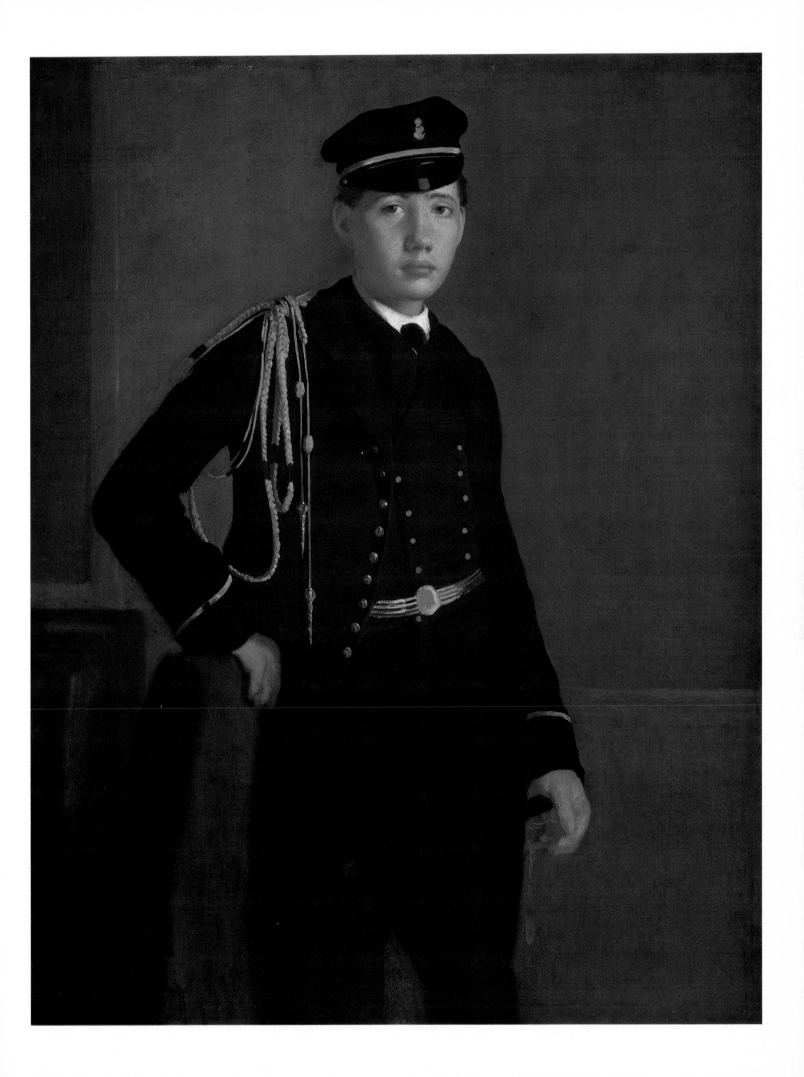

Painted 1860

SPARTAN GIRLS AND BOYS EXERCISING

Oil on canvas, 42 7/8" × 61"

The National Gallery, London

This is the most lively, fresh, and attractive of Degas' early attempts to paint a large historical composition. Following the Neo-Classical tradition of the nineteenth century, he chose a respectable subject from the Greek or Roman past, here Lycurgus and the older women of Sparta watching the boys and girls of the city at their games. Like many other Neo-Classical artists, he linked his composition to that of the Renaissance; this picture, he tells us in one of his notebooks, is based on a drawing by Pontormo, the sixteenth-century Italian master.

He made many drawings and studies in preparation for the final canvas. At one time he planned to insert a classic temple in the center and place his right-hand group of figures against a series of tree trunks. But he rejected such trite and old-fashioned ideas. From the boys and girls of Montmartre, the children he saw round him every day, Degas chose his models; they are the thin, wiry youngsters of the Quarter and he has accented their Parisian, rather than their Spartan, appearance. The action between the two groups is carefully studied; poses are repeated or contrasted, while the background group (as in many fifteenth- or sixteenth-century Italian compositions) links the left and right elements of the design.

The Neo-Classical heritage is felt chiefly in the thorough modeling of the figures which stand out in an effect of bas-relief and in the rather empty, spacious landscape which surrounds them. While in the earlier studies Degas had intended to use a cold, somewhat petrifying color scheme, based remotely on antique sculpture, in the large picture he warmed up the tones of the flesh and the whole golden light which pervades the composition.

Of future interest is the group of the girls; already at so early a date Degas has found a way of combining movements of several figures into a single unit; these crossing legs and out-flung arms foretell similar studies in ballet dancers of fifteen years later. The piquant charm of the girls gives an individual reality to the picture and shows how much Degas stressed this quality whenever he painted girls or young women.

Spartan Girls and Boys Exercising was not exhibited for some twenty years after he finished it. Then Degas suddenly sent it to the Fifth Impressionist Exhibition where it must have looked strangely out of place in the dazzling company of his later, more brilliant paintings and pastels.

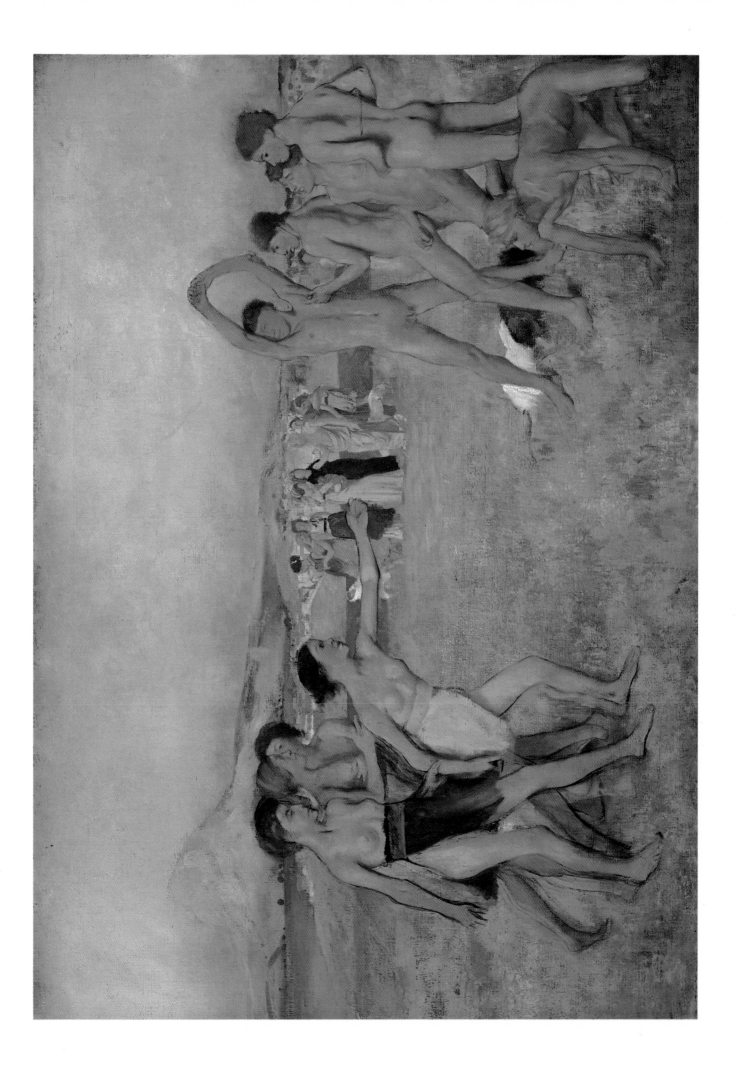

Painted about 1860-1862

THE BELLELLI FAMILY

Oil on canvas, 78³/₄″ × 99⁵/₈″

The Louvre, Paris

On a trip to Naples in 1856 Degas visited his aunt, the Baroness Bellelli, and began a series of little portraits and drawings of her family; he wove these, and many more preliminary drawings, and sketches in oil and pastel, into this life-size group portrait of his uncle and aunt and their two daughters in their own drawing room.

Today, there is nothing original in such a conception, but in the fifties in France the plan of showing a family in its own environment was audacious and unusual. In one of his notebooks Degas mentions doing " portraits of people in familiar and typical attitudes, above all giving to their faces the same choice of expression as one gives to their bodies." With this in mind he sought to characterize each of the four individuals and at the same time compose a picture which would satisfy the exacting requirements of the Florentine masters whose works he saw daily in the art galleries.

The dignified standing figure of the Baroness, the contrasting poses of the little girls, the brusquely indicated profile of the Baron, turning in his chair; Degas studied each until he found the revealing attitude. Then he arranged the four in a moment of pause between actions, managing to suggest, with great restraint, a certain dramatic interplay of personalities.

The design of the picture is based on a series of rectangles, against which play the curves of the figures. In this severe structure of right angles (echoed most obviously in the framed drawing on the wall of Auguste De Gas, his father, and brother of the Baroness) one sees Degas' pronounced love for the masters of the early Renaissance and for Holbein, whose drawings he assiduously studied. Relieving the monotony are the charmingly painted details of the room, the patterned wallpaper and rug, the touches of gold and black, the reflecting mirror—a typical Degas device to secure space and suggest a fourth wall to the interior. The contrast of blacks and whites, the harmony of blues and tans, make a great advance over the low keyed portrait of Achille (page 47). Bringing the composition to life is the gentle, revealing and yet suffusing light which reminds one of Corot.

The Bellelli Family remains the painter's first important and original work. Typically cool and aloof on the surface, it contains the promise of Degas' later audacities in portraiture and shows the precocious mastery of the young painter. Today it is one of the glories of the Louvre.

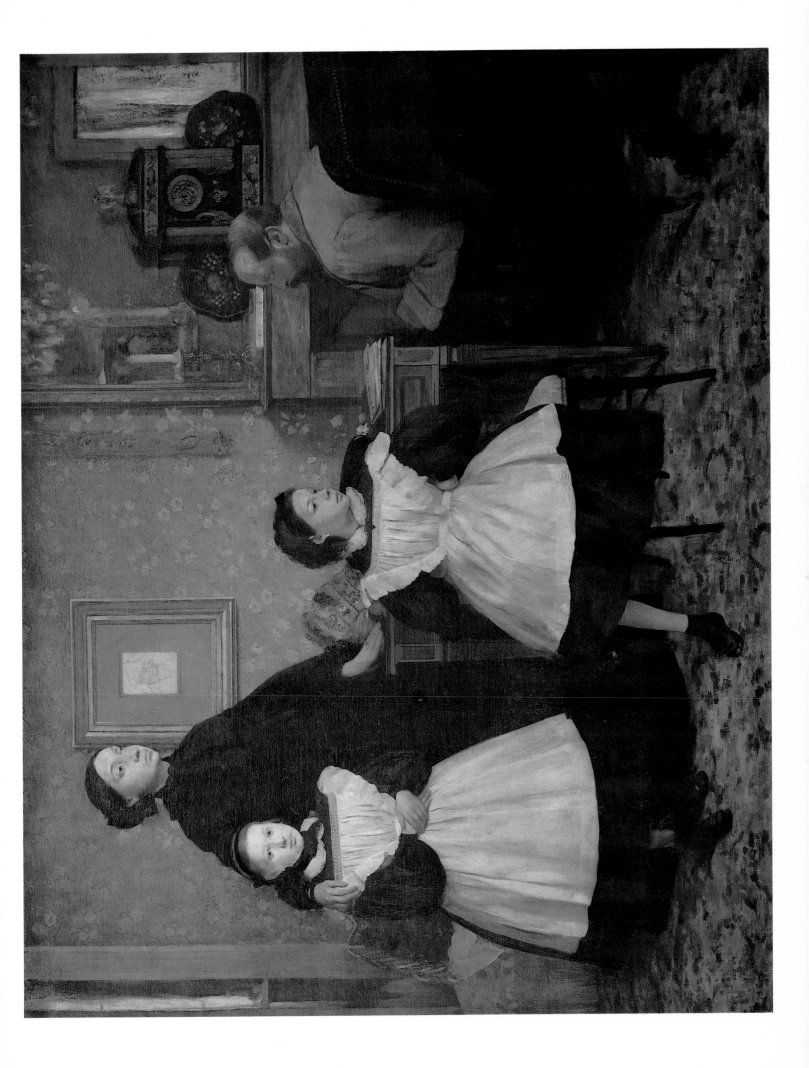

Painted 1867

HEAD OF A YOUNG WOMAN

Oil on canvas, 10 ⁵/₈" × 8 ⁵/₈"

The Louvre, Paris

The woman who posed for this exquisite portrait is unknown; she can hardly have been (as was once seriously suggested) the Duchess Morbilli, who was sixty-two years old in 1867.

With the simplest means Degas made a living portrait out of what a lesser painter would have turned into a mere study of a head. The face is not that of a beautiful woman; a few years later the artist was to write from New Orleans: " The women here are almost all pretty and many have even amidst their charms that touch of ugliness without which, no salvation." Always seeking character rather than formal beauty, the painter has not minimized her largish nose or corrected the slant of her left eye. The use of a few restrained tones (note how the black of her gown is repeated in the ribbon which binds her hair) and the most subtle rendering of form and delicate gradations in brushwork create a remarkable work of art.

Such a portrait unites the best of the Italian tradition and the style of earlier French masters like Clouet and Corneille de Lyon. Those who have dismissed Degas as a misogynist should study the tenderness and understanding with which he early painted portraits of women.

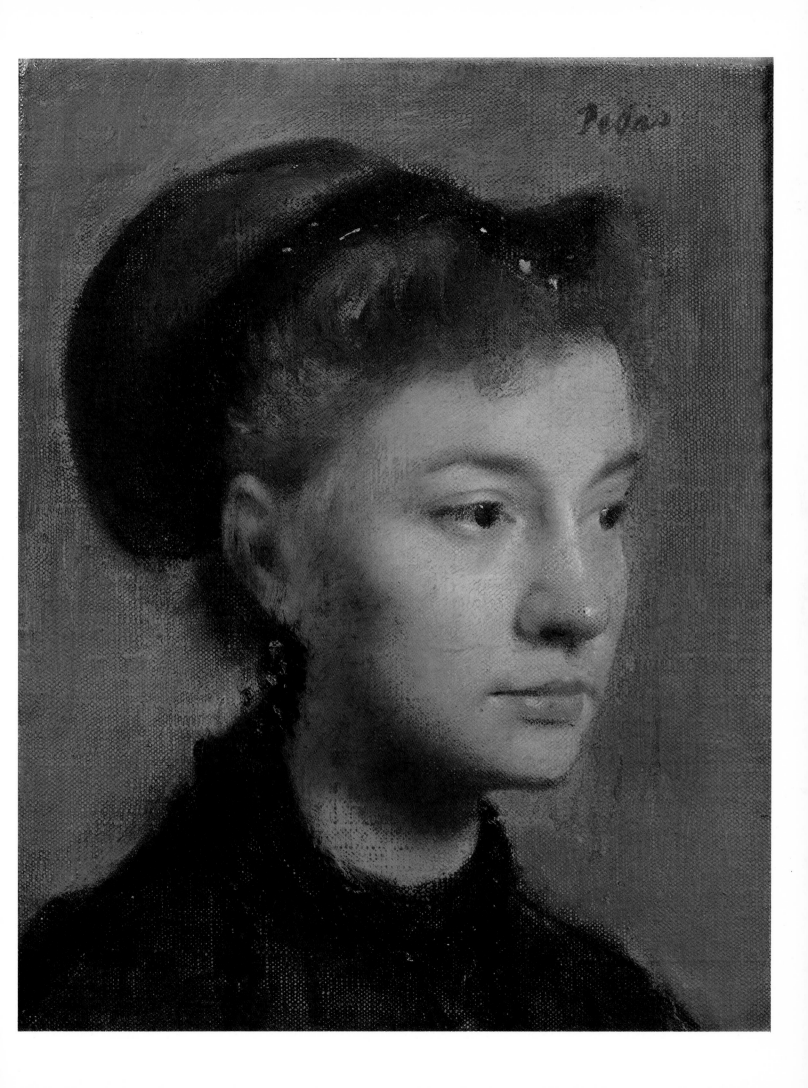

Painted 1867

M. AND MME. EDMOND MORBILLI

Oil on canvas, 45 ⁵/₈″ × 35″

Museum of Fine Arts, Boston

In 1863 Thérèse De Gas, a younger sister of the painter, married her cousin, Edmond Morbilli, of a noble Italian family. Soon afterwards Degas painted the charming double portrait (*The Duke and Duchess of Morbilli*) which is now in the Chester Dale Collection at the National Gallery in Washington. In it he continued the series of family studies begun in *The Bellelli Family* (page 53), setting his figures casually in their drawing room and endowing them with a new liveliness and ease.

Three years later he finished this brilliant and commanding portrait which seems to recall, with remarkable vigor, Degas' double interest in realism and tradition. Gone are the carefully painted details of the interior; these figures powerfully fill the canvas against a neutral background. Degas here shows himself as much of a painter as a draftsman in the way he has solidly constructed the body as well as the head and hands of Morbilli. He has stressed the pride, if not the arrogance, of the young Italian, who completely dominates the composition, recalling in his pose certain earlier portraits by Pontormo and the Venetian masters. By his side, Mme. Morbilli, with her shy gestures and intense gaze (the resemblance to the painter is here quite striking), furnishes a delicate foil. Movement is gained by the thrust of Morbilli's chair, which is echoed in crossed diagonals of his legs, the folds of his coat, the trimming on Mme. Morbilli's dress. The embroidered tablecloth, with its black and gold design, adds a note of almost exotic blues, contrasted with browns and tans and blacks which Degas loved and from which in this moment he wrought an exquisite harmony. Though in dignity and a kind of ample grandeur the portrait completely transcends photography, it is not impossible that Degas was struck by the rich effects of light and dark and the ability to catch a fleeting likeness which the camera afforded. Such an influence, if indeed it existed, is hardly apparent, for Degas knew how to absorb its ideas as he absorbed the ideas of the masters and give them a wholly fresh form.

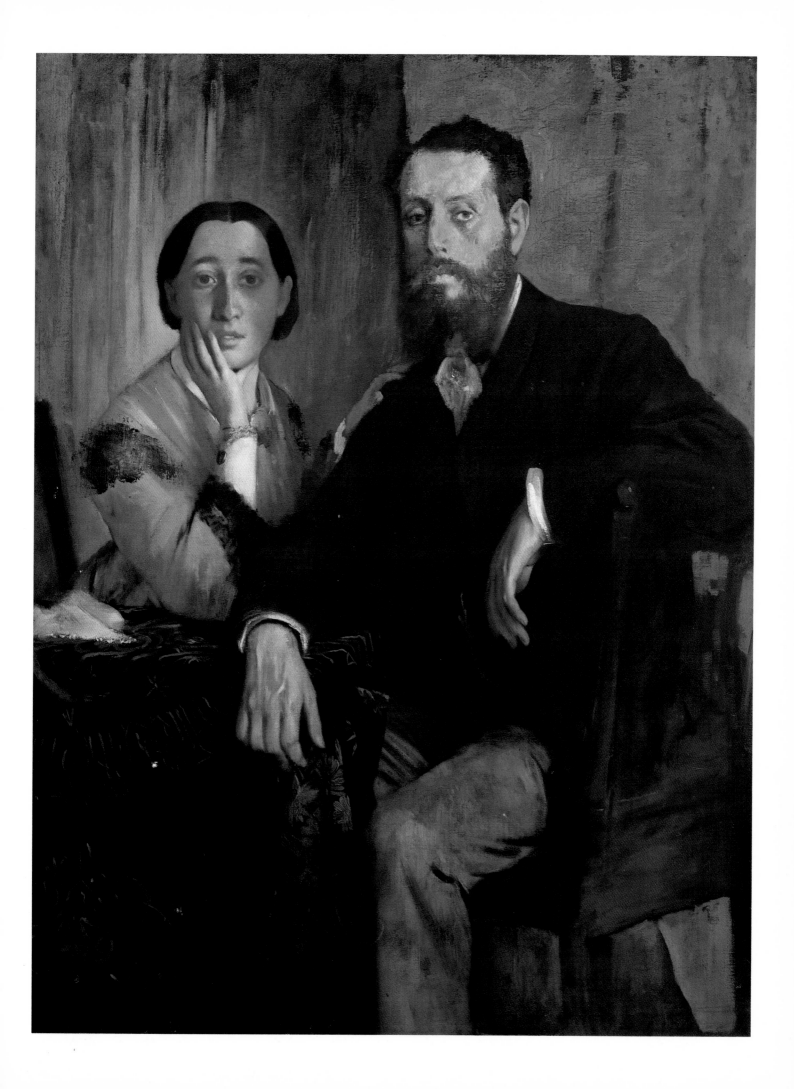

Painted 1869

HORTENSE VALPINÇON AS A CHILD

Oil on canvas, 28³/₄″ × 43¹/₄″

Minneapolis Institute of Arts

Degas had a special sympathy for children and there are a number of testimonials to the fact that, gruff as he often was with adults, he enjoyed the company of the sons and daughters of his friends as well as his own nieces and nephews. It was probably on one of his trips to Normandy where he often visited the Paul Valpinçons that he painted this charming and unsentimental portrait of Hortense.

The artist has contrasted the little girl in her simple white pinafore and hat with the richly, brightly colored designs of the cloth and stuffs on the table. The patterned background on the wall repeats in a milder key the colors and shapes of the foreground, while the natural pose of the child is seized with a seeming effortlessness. As usual at this period, the head is carefully modeled and the face delicately drawn. Perhaps Degas left it purposely a little unfinished for there are light lines of correction along the right profile of the figure which show that he had another idea for this area of the canvas. Many years later Degas modeled a large bust of Hortense Valpinçon which unfortunately was poorly cast and exists today only through descriptions and a casual sketch in one of his letters.

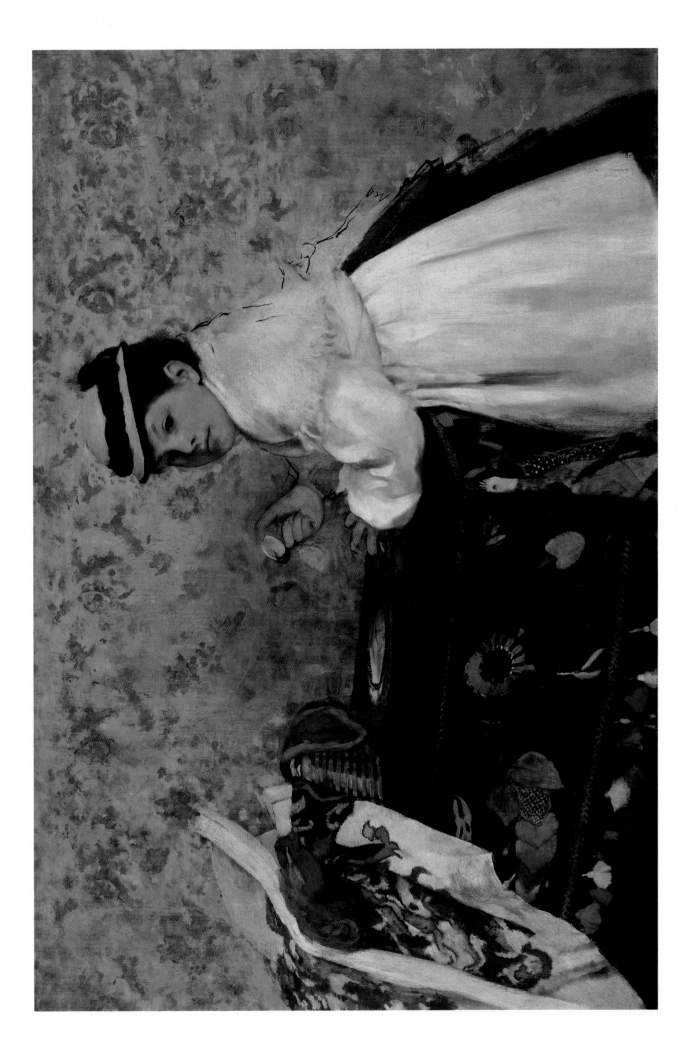

Painted about 1869-1872

DEGAS' FATHER LISTENING TO PAGANS

Oil on canvas, 31¹/₂″ × 24³/₄″

Museum of Fine Arts, Boston (John T. Spaulding Collection)

There are a number of paintings by Degas in which with exquisite tact he studied people listening to music. Auguste De Gas, the father of the artist, was a great enthusiast of Italian music and himself a successful amateur musician. Lorenzo Pagans, a Spanish singer, was celebrated in Paris, appearing in many concerts where he accompanied himself on the guitar. He often took part in musical evenings at the homes of Degas and Manet.

This is the second of three portraits Degas painted on the same theme. The first (today in the Louvre) is more conventional, showing Pagans seated, in full-face, with the father listening in the background. In the version reproduced here Degas gave a more intense expression to the moment, contrasting the erect figure of the singer, pushed to the left, with the bent, aging old man on the right; the canvas is daringly divided by the vertical of the guitar, and the contrast deepened by silhouetting the profile of Pagans and placing the head of Auguste against an open sheet of music. The execution is freer and more sketchy, Degas' brush supplying short accents which build the form and yet give an impromptu and casual effect to the unusual composition. There is relatively little color, the tans, browns, grays, and whites contributing to a restrained tonal harmony.

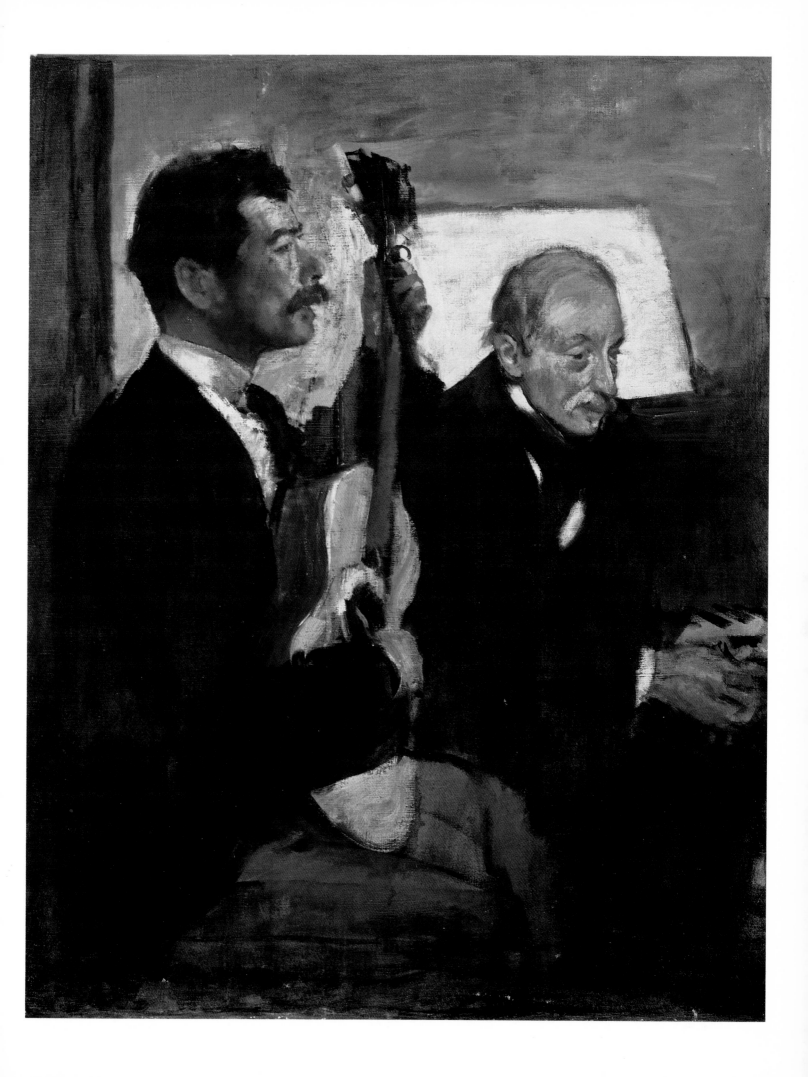

Painted 1869-1872

AT THE RACE COURSE

Essence on canvas, 18¹/₈″ × 24″

The Louvre, Paris

Degas' pictures of the race track, unlike those of Manet done at the same period, which stress the blur and rapid movement of the early Impressionist vision, are most often concerned with the riders parading in front of the grandstands in the cool, pale sunlight of Paris.

The artist's love of silhouettes is clearly seen in this one where he has simplified the horses by painting them broadly and flatly against the sun, their shadows cast on the grass in an almost Oriental fashion. His vigorously painted outlines give the composition a decorative character; the repetition of browns, in varying shades, is echoed in the grandstand and contrasted with the reds and blues and dull yellows of the clothing of the riders and spectators.

This is also a scene, Degas makes us remember, from daily life. He shows us the movement of the crowd on the left and gives a countermovement of the riders on the right, the design being carefully planned through perspective by diminishing the size of the retreating figures in two diagonals to the center distance, and by the line of the fence. He has not ignored the stacks of factories and the ornamental detail of the grandstand. The two largest riders, one facing to the left, the other to the right, break the monotony of the composition and give us a sense of being in the very midst of the scene.

Degas' search for fresh pictorial effects led him to continued experiments in technique as well as in other directions. To get a substance which would dry quickly and lend itself to a draftsman's handling Degas dried the oil from his pigments and mixed them with a volatile spirit, perhaps turpentine; the term " essence " has been used to designate this medium.

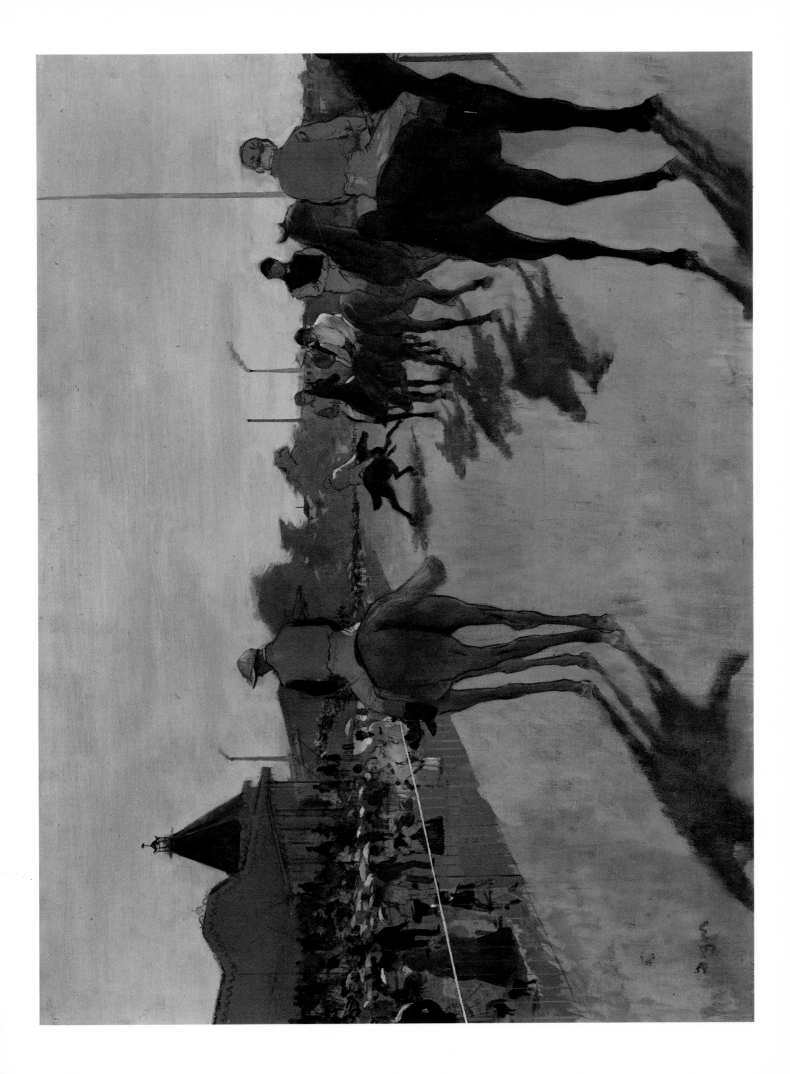

Painted 1870-1873

A CARRIAGE AT THE RACES

Oil on canvas, $14^1/8" \times 21^5/8"$

Museum of Fine Arts, Boston

Degas' eye at the races often strayed to the spectators as well as the jockeys, and in this delightful small picture he has given us a scene of elegance and charm completely embodying French life of the period. In its day the composition must have seemed unusually daring, for the principal element in the design—the victoria of the gentleman driver—is placed in the bottom right of the canvas and sharply cut by the frame. Degas undoubtedly derived this point of view from photography, in which he had become deeply interested at this time.

More important today is the controlled artistry with which the whole picture is planned and painted. " The most beautiful things in art come from renunciation," the painter was fond of saying, and he has here severely limited his colors to a few finely attuned and grayed hues. Here and there a stronger note balances the cool springtime green of the field and the delicate neutral sky, itself a miracle of subtle, atmospheric painting. Compared to the broken color and striking effects of light that the Impressionists were then employing, *A Carriage at the Races* seems definitely traditional, harking back to the harmonies of Corot rather than paralleling the color experiments of Monet. The firm, decisive drawing contributes to the clarity of the conception while the flat technique recalls the fact that Degas insisted that " nature was smooth."

Amusing, as social comment, is the insistence of the English character of the scene—the victoria, the driver's top hat, the bulldog. English styles were then much the fashion in France among the upper classes.

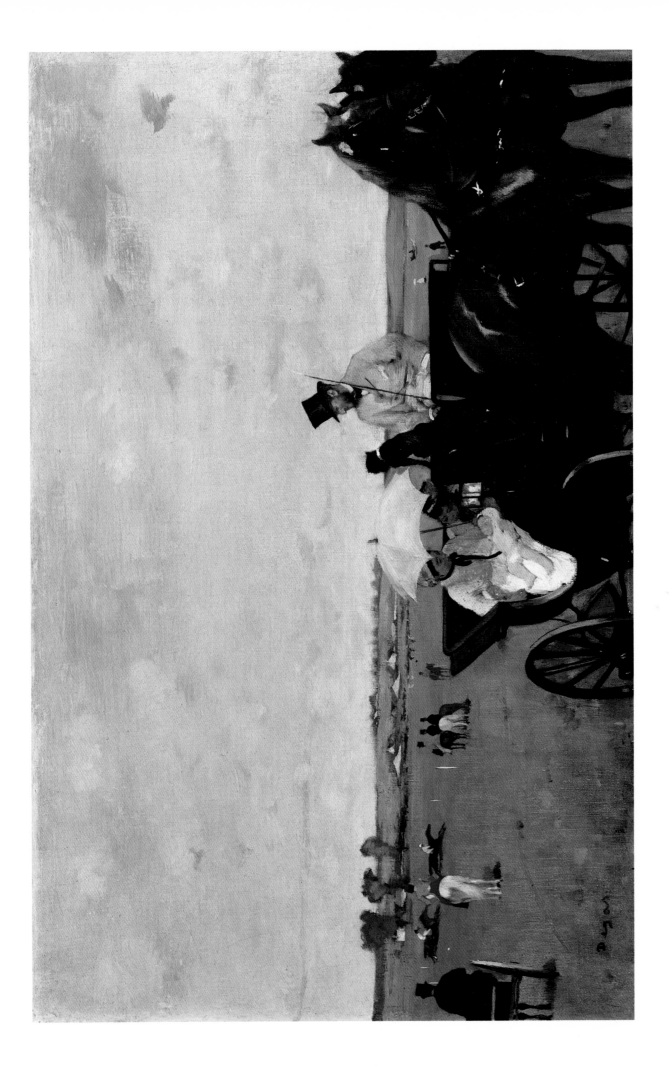

Painted 1872

THE DANCE FOYER AT THE OPERA

Oil on canvas, 12 ⁵/₈″ × 18 ¹/₈″

The Louvre, Paris

Degas' first treatment of the ballet dancers at the Paris Opera was coolly objective and most carefully studied. Each figure was first sketched (see page 20) and then combined with others into the broken frieze of dancers which stretches in a subtly varied manner across the whole picture. He was not ready, yet, to set his figures in motion but preferred to represent them as taking their preparatory positions or practicing at the bar.

Here in the somewhat static Louvre picture opposite, we note that the details of the architectural setting are used to frame groups of figures and lend stability by repeated verticals and horizontals. Space is suggested by the open doorway on the left and the shifting reflections in the central mirror, as well as by the chair in the foreground which helps to create an illusion of depth. The light, entering from the right, falls clearly across the scene, and a repeated white is contrasted with dark notes in the sashes, neckbands, and the suit and music stand of the violinist. A recent student of the ballet finds that Degas has enlivened the ballet costumes of the day with bright sashes and black ribbons of his own invention; these little touches combined with the red line of the practice bar add a decorative charm.

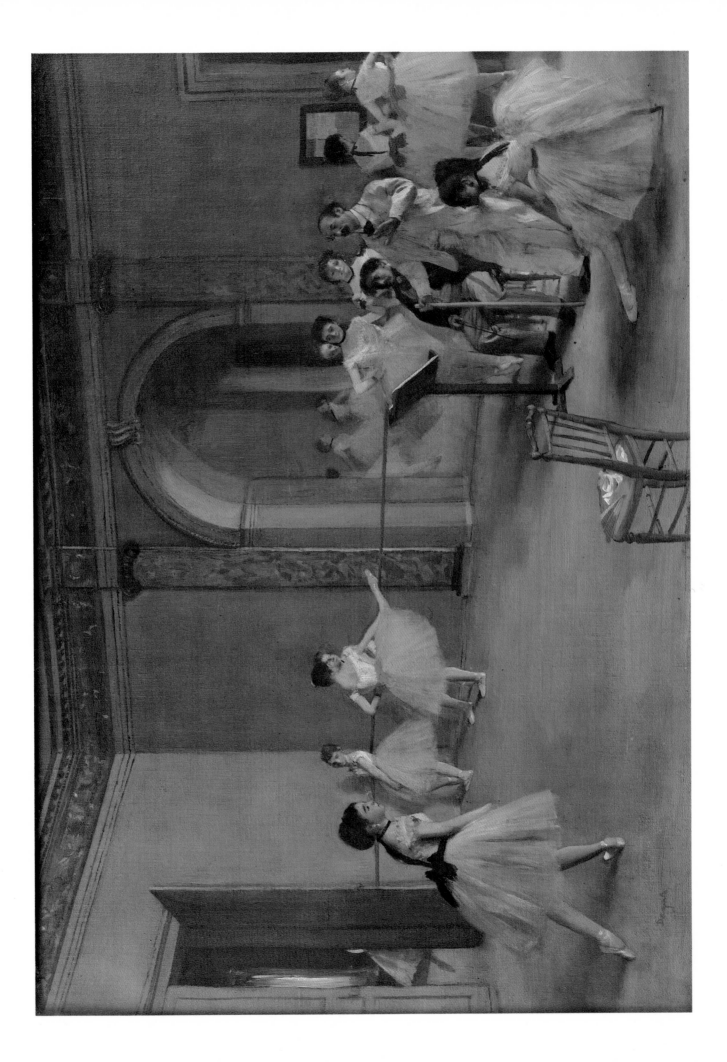

Painted 1872-1873

MME. RENÉ DE GAS

Oil on canvas, 28³/₄" × 36¹/₄"

National Gallery of Art, Washington, D.C. (Chester Dale Collection)

Never able to stop painting, Degas on his visit to New Orleans did several portraits of his family, of which this is the most successful. He grumbled a good deal over them. " The family portraits," he wrote to a friend, " they have to be done more or less to suit the family taste, by impossible lighting, very much disturbed, with models full of affection but a little *sans-gêne* and taking you far less seriously because you are their nephew or their cousin." But his sympathy for his sister-in-law, Estelle Musson, hopelessly blind, here created a subtle and delightful portrait.

Degas' brush never moved more deftly or lightly than in this silvery portrait. John Rewald, who studied these American subjects, believes that the artist painted her just before the birth of her fourth child, for whom Degas was to stand as godfather; and that her ample gown was chosen to hide her condition. But there is an artistic, as well as a biographical, side to such a composition. The artist found " the tenderness of the eighteenth century " in the manner of his New Orleans family and there is something of the grace and delicacy of another age which he gave to the sitter. Perhaps, as has been suggested, she is listening to music, for Degas often painted people at these moments. She was herself a talented musician and loved opera. Beyond that he has managed to suggest, in a most convincing way, the loneliness of the blind—the overly calm pose, the sightless, open eyes, turned away from the spectator. This feeling accords strangely, but effectively, with the exquisite light which fills the canvas, and the delicate reiteration of the whites and grays and pale rose in the color scheme.

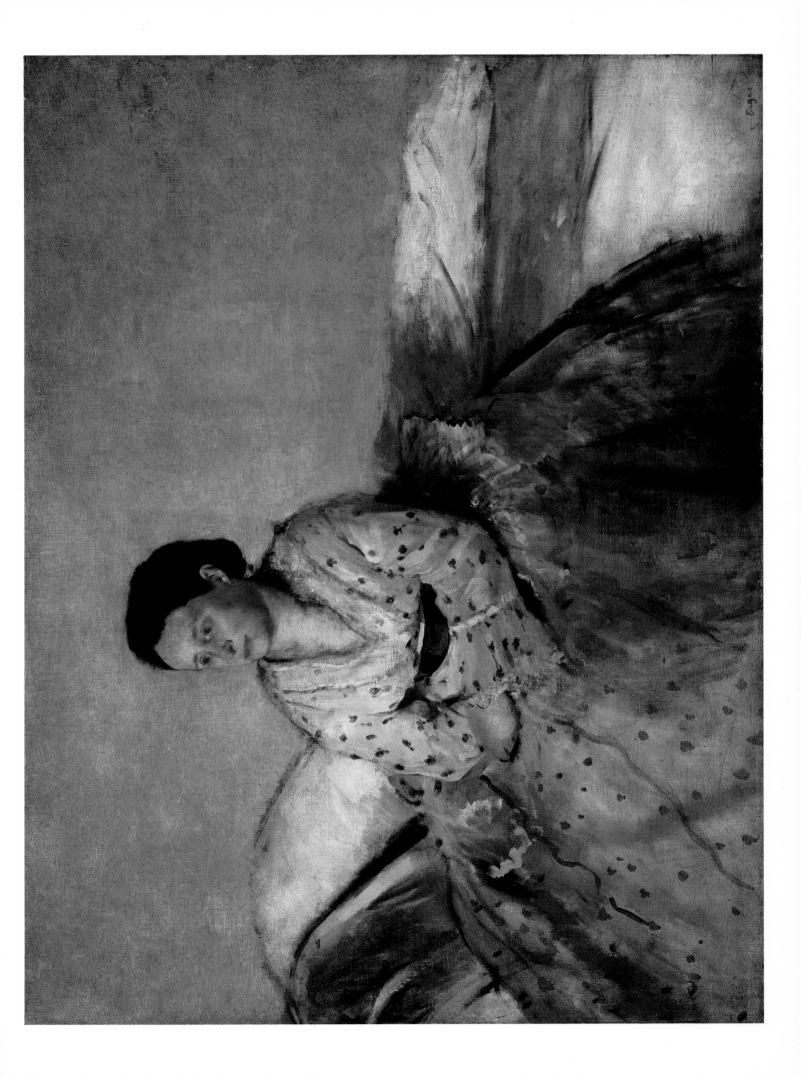

Painted 1873

THE COTTON MARKET, NEW ORLEANS

Oil on canvas, 29 ¹/₈″ × 36 ¹/₄″

Musée des Beaux-Arts, Pau, France

"I have attached myself to a fairly vigorous picture," Degas wrote in 1873 from New Orleans to his friend, the painter Tissot, "which is destined for Agnew (the English picture dealer) and which he should place in Manchester. For if a spinner ever wished to find his painter, he really ought to hit upon me. The Interior of a Cotton Buyers' Office in New Orleans.

"In it are about fifteen individuals more or less occupied with a table covered with the precious material, and two men, one half-leaning and the other half-sitting on it; the buyer and the broker are discussing a pattern. A raw picture if there ever was one..."

He had gone to America to visit his brothers who were in the cotton business and his desire was to paint a series of recognizable individuals in characteristic action. John Rewald, who made a careful study of the people involved, identifies the elderly gentleman in the foreground who is testing a sample as Michel Musson, the father-in-law of René De Gas. At the extreme right is the cashier, John Livandais, standing over account books. In the center is René reading the local newspaper, the *Times-Picayune*. On a high stool is James Prestidge, who is conversing with a customer making notes in a memorandum book, while William Bell, another son-in-law of Musson, sits on a table covered with cotton. Achille, Degas' other brother, leans negligently against a window in the extreme left, observing the scene.

To unify the picture Degas played a series of irregular white shapes (the cotton, the newspaper, the books, etc.) against the dark clothes of the figures. Shrewdly he composed the architecture of the room with its repeated rectangles back into distance, carefully increasing detail in the foreground, and overlapping one figure by another to give an effect of perspective as the figures diminish in size. The eye level, looking down on the seated figure of Musson, and the slanting floor contribute to the illusion of space. In so complicated a scheme, color is minimized and Degas' brilliant drawing, recording a gesture here, a pose there, binds the whole composition together. No Neo-Classical painting was ever more carefully designed, and the final effect is a balance between a sensation of movement and bustle, and a clarity which is superphotographic. In addition the picture remains a faithful and sympathetic document of a vanished period. It was one of the first of Degas' works to enter a museum, being purchased by the city of Pau as early as 1878.

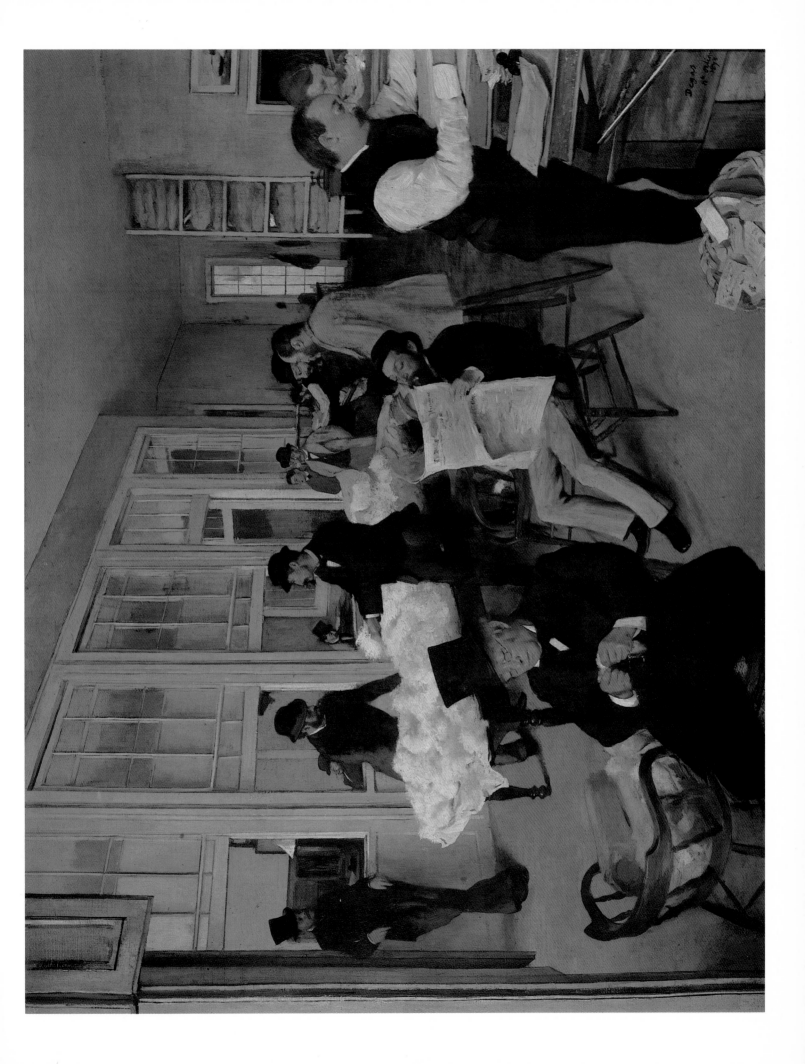

Painted about 1873

THE REHEARSAL

Oil on canvas, 31 ⁷/₈″ × 25 ⁵/₈″

The Dumbarton Oaks Collections, Washington, D.C.

Degas must have witnessed many such scenes in his own home, for his father was passionately fond of music and various talented performers were constantly on hand for musical evenings. Here he used his sister, Marguerite, herself an accomplished singer, for both women—a characteristic Degas touch. His conception of personality seems to have been that with each new moment one became a new person, and he liked to paint the same model over and over, seeking a different meaning in each attempt.

This picture, with its delightful and unusual color scheme, gives off the atmosphere of the Second Empire but at the same time shows the artist's originality. He has angled the room to suggest a snapshot view and caught a suspended moment of action with an almost camera-like fidelity. The opposition between the two figures sets up a tension to which the interval of space between them importantly contributes. Undoubtedly, as certain ground plans of his paintings indicate, Degas imagined a real setting into which he inserted his figures, brilliantly employing perspective to heighten the effect. Here the scattering of the furniture round the empty space in the center and the unusual eye level intensify the feeling that we have suddenly come into a room and caught the three figures in a dramatic moment. With what restraint and skill has Degas rendered their significant gestures!

The sketchy state of the picture shows that it is unfinished. For some reason or other the artist put it by and it appeared only at the sale held after his death.

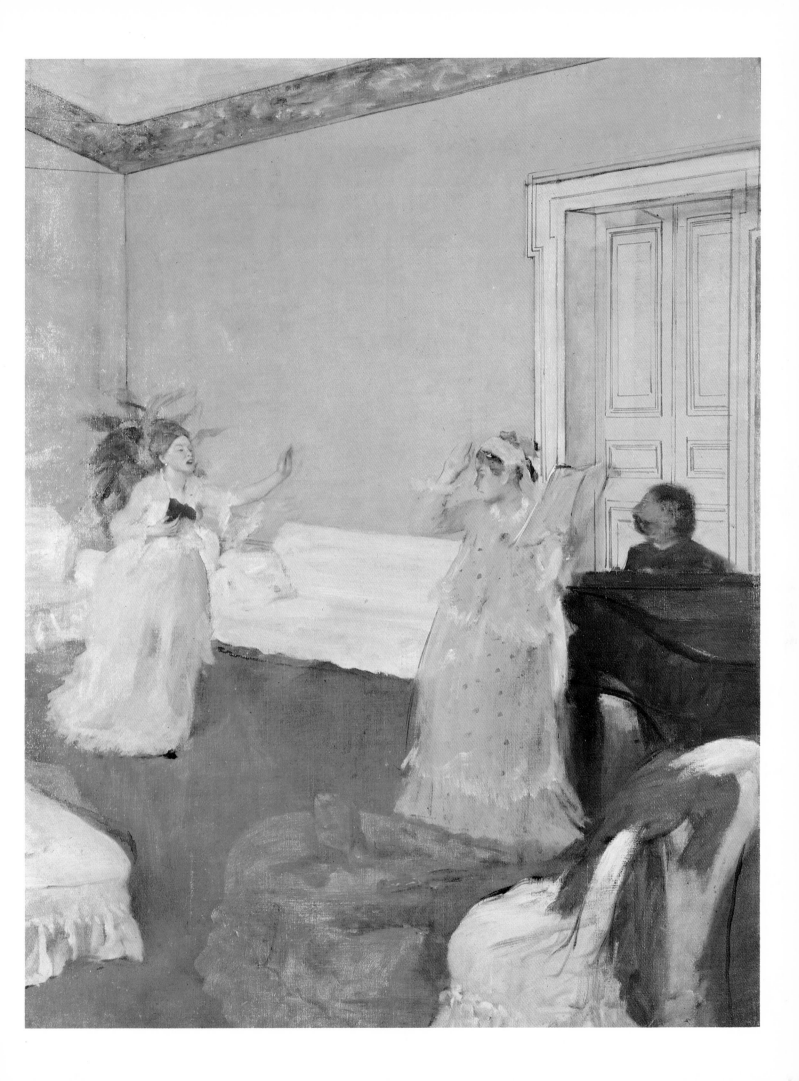

Painted 1873-1875

POUTING

Oil on canvas, 12⁵/₈″ × 18¹/₈″

The Metropolitan Museum of Art, New York
(The H.O. Havemeyer Collection. Bequest of Mrs. H.O. Havemeyer, 1929)

Degas was not above exploring the typical storytelling picture of the day, the half-artistic, half-literary form which delighted the public of the nineteenth century. Only he gave it a new twist; he left out the exact story to suggest a more general human situation. In this exquisitely rendered little canvas he employed the maximum contrast of the young woman leaning naturally across the chair, with the hunched bitter figure of the man looking out of the picture. Is this social comedy, irony, hidden tragedy? We do not know, for the artist has carefully refrained from making a comment. All we see is a moment of domestic life, painted with an extraordinary realism such as the Dutch masters of the seventeenth century might have employed. The gray blues, corals, browns, and blacks are carefully balanced in an unusual harmony; the drawing of expressions and pose is most trenchant, and the whole informal, seemingly spontaneous composition is studied with unusual care. Typical is the device of the picture on the wall behind, silhouetting the two heads and binding them together. While the movement of forms is distinctly from left to right, the running horses in the picture return the eye to the center of interest and help create a generous curve into which the two figures are fitted. Degas' brush was never more sensitive nor exact than in the finish of this small painting.

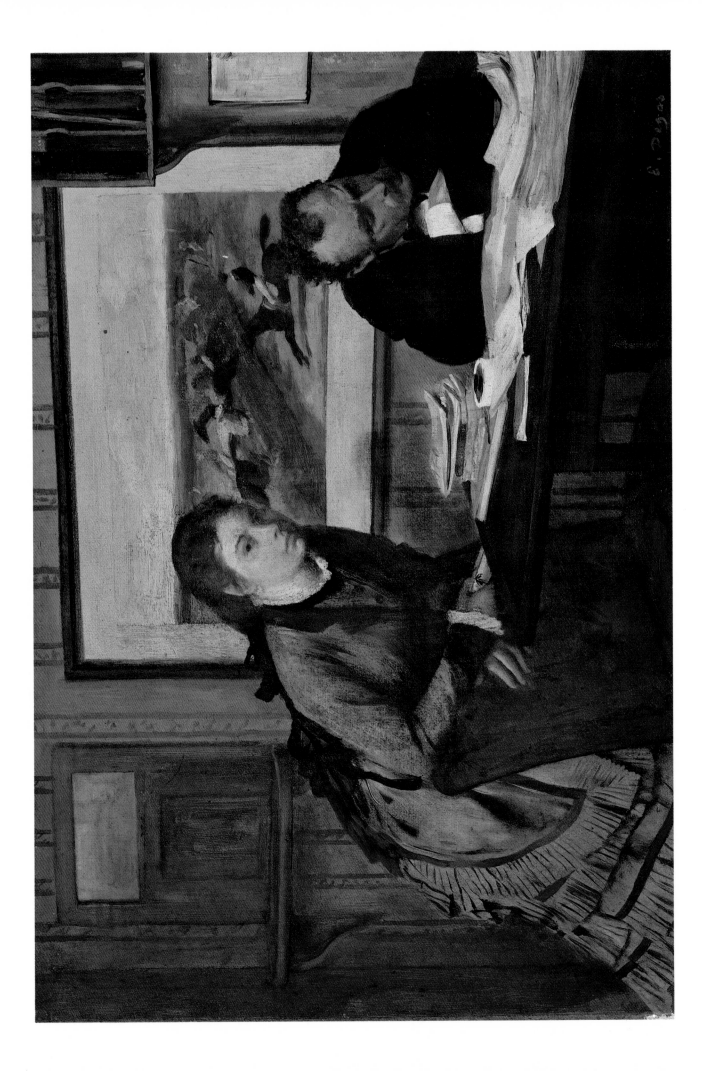

Painted about 1874

MELANCHOLY

Oil on canvas, 7 ¹/₂" × 9 ³/₈"

The Phillips Collection, Washington, D.C.

Seldom did the artist paint with such deep feeling as in this small picture where an arresting composition is balanced by profound psychological insight. Always alert to find new effects of lighting, Degas must often have seen a face take on unexpected aspects when firelight played over it; here he captured these subtle reflections, contrasting them with daylight which floods the background of the canvas. The thrust of the figure into a tense, almost cramped pose is daringly emphasized by the line of the sofa, while the harmony of browns and reds helps to fix attention on the intensely rendered features. Nothing intrudes to spoil this unity of effect and it is typical of Degas that the fireplace is only suggested and not included in the design.

Most often the artist refused to depict in his portraits the outward signs of a deep interior life. A classical restraint kept Degas from seizing moments of despair or stress; he preferred a formal calm. But here he has portrayed a more profound mood. This unknown model staring into the fire stares into herself; the face is subtly charged with the marks of her introspection. It is interesting to note that the somewhat literary title, *Melancholy*, is not of Degas' choosing. Earlier the picture had been called simply *Young Woman Seated on a Sofa*, and it is very probable that the artist would have disdained any other name for it.

Painted 1875-1876

WOMEN COMBING THEIR HAIR

Essence on paper, 12¹/₄″ × 17³/₄″

The Phillips Collection, Washington, D.C.

Though seemingly a composition of three women, the model is evidently the same girl seen in three different poses and combined into a single picture. This idea of putting together in one composition multiple views of one model is new to art, and Degas used it over and over again. Here he has added a background to suggest a beach, and in the upper background a touch of green, to suggest grass and trees.

The drawing is delicately incisive, capturing the form of the figures with a masterly grace. Here and there the artist has added more solid modeling to suggest a kind of sculptural approach, or accented a line or profile to give strength to his design. The repetitions, of the whites in the dresses and the tones of the hair, unify this unusual composition. Later Degas in his sculpture would condense many views of the same figure into three-dimensional form. The naturalness of the subject is somewhat new to painting. Before Degas, few artists treated woman at such homely and unconventional pursuits. Later he would spend years of his life at such themes, exploring every gesture and movement of this kind.

Painted 1875-1877

CAFÉ-CONCERT: THE SONG OF THE DOG

Gouache and pastel on paper, 21 ⁵/₈″ × 17 ³/₄″

Private Collection

In those pictures which Degas made from the night cafés in the Champs Elysées, he seems to have been struck by the vigorous vulgarity of the performers. Unlike the charm with which he rendered his first ballet dancers, these works are sharply satirical. As Mrs. Havemeyer, who bought the picture from Degas, wrote, " There is nothing elegant about this woman's pose. Her hands suggest the movement of a dog (from a popular song of the period) and the gesture is done as only Degas could do it with a flash of drawing. The lines of the mouth, as she bawls forth the vulgar song, her exultant exaggeration, showing she is conscious of her power over her audience, all this and much more... show clearly what the *café-chantant* is, what part it plays in Parisian life, the kind of creature that furnishes the amusement, and, although you cannot see them distinctly, you know the class of pleasure seekers who can be entertained by such a performance."

Here Degas has superbly rendered the effect of night atmosphere with its dark green background against which plays the tawny hair of the singer. He placed the profile strongly against a yellow pillar which cuts the composition, and contrasted the face, lighted drastically by footlights, with a repeated pattern of electric globes—devices which show that by this time he was absorbing the patterns of Japanese art. It is interesting to note that he has twice enlarged the picture by adding strips of paper to the right and working over them. Painted chiefly in gouache, the colors have been strengthened and the forms accented by strokes of pastel on top of the gouache.

Degas would do a series of pictures on a single theme, studying it from every angle; among his variations on the entertainers in cafés is a remarkably vivid work, a close-up, the *Café Singer* (see page 32), painted in 1878, and belonging to the Fogg Art Museum, Harvard University (Maurice Wertheim Collection). Always Degas tried, as he progressed, to summarize and condense his meaning, eliminating detail and enlarging his vision. His has represented this *chanteuse* in a moment of intense action, with her mouth open in song, one black-gloved arm flung up for emphasis. The placing of the singer in the frame is brilliantly studied so that the eye unconsciously completes the rest of the figure while the whole idea—so daring for the 1870's—seems to foretell the close-up of the motion picture, as yet uninvented. The detail of the black glove was to haunt Toulouse-Lautrec, who adapted it to his many studies of the French singer, Yvette Guilbert.

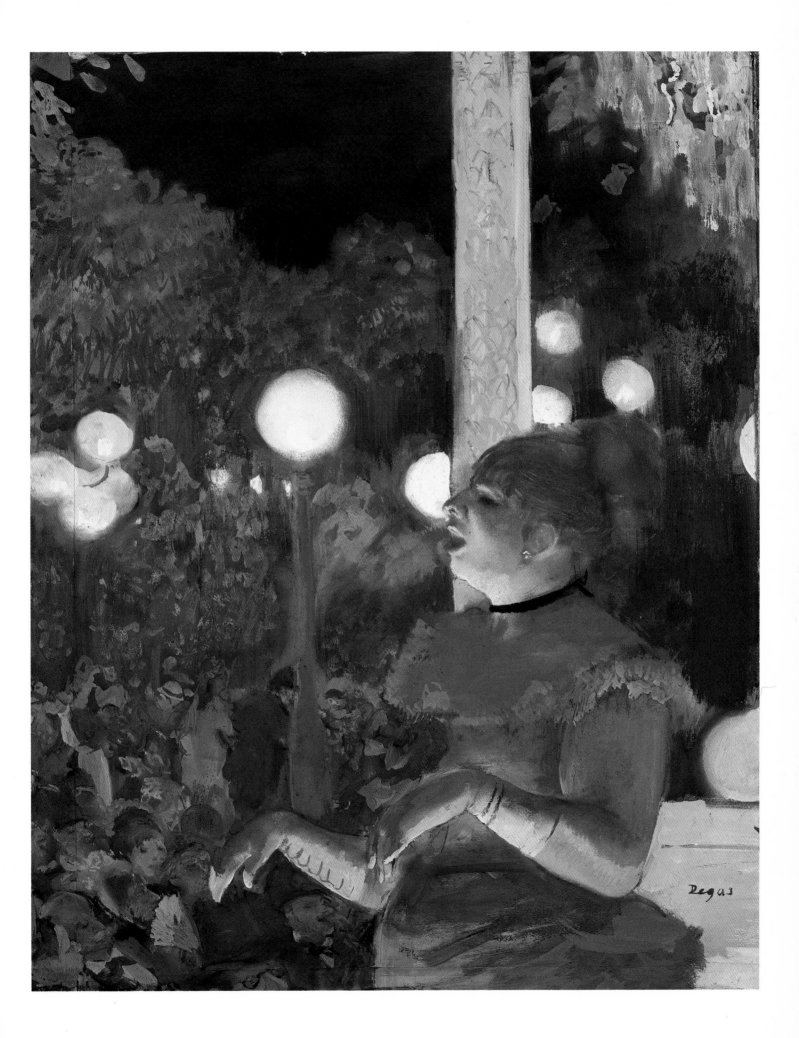

Painted about 1876

THE DANCING CLASS

Oil on canvas, 32⁵/₈″ × 29⁷/₈″

Private Collection

Compared to Degas' earlier treatment of the dancing class in the Opera in rue
Le Peletier, this painting shows how quickly the artist advanced into the world
of movement and casual effect which he was to make his own. Larger in size,
broader, freer, and lighter in treatment, it is full of many impressions, gathered
into a remarkably complex design. Perspective is here cultivated by the slanting
floor and by the diagonal line of dancers, starting in the left foreground and con-
tinuing back into the farthest corner. The picture space is widened by a mirror
catching reflections of other dancers and a window beyond. What intense study
has gone into each ballerina! Each is caught in an individual pose and gesture and
for the first time the artist has attempted a figure in action. All the bustle and
confusion of many movements is caught with an almost camera-like fidelity.
Degas cuts off one figure by another, overlapping forms easily and masterfully,
but so shrewdly are they fitted together that there is no real confusion. Against
all this turning, twisting, and posing stands the rock-like form of Maître Jules
Perrot, leaning heavily on his stick. Behind, in further contrast, are mothers
watching the class, their street clothes furnishing a foil for the light, graceful
costumes of the dancers. Here was something new in art, a surprising view of a
little-known world, composed with the grace and authority of an old master.

Painted 1876

ABSINTHE

Oil on canvas, 36 1/4″ × 26 3/4″

The Louvre, Paris

Of all of Degas' scenes of café life, this is the most famous. When it was shown in London in 1893 it created a scandal, the Victorian public being unprepared for so disenchanted a picture of Parisian life. The title, as well, suggested depravity and it was widely attacked by conservative artists like Walter Crane and as stoutly defended by Walter Sickert and George Moore. Degas himself must have been surprised at such English vehemence. He had posed two of his friends, the etcher, Marcellin Desboutin, and the actress, Ellen Andrée, on the terrace of the Nouvelle-Athènes Café in the Place Pigalle, a spot much frequented by the artists of the day.

The design is among the most brilliant inventions of the artist. From Japanese prints he had learned this zigzag arrangement of lines which, beginning in the bottom of the canvas, is carried swiftly back by the blank table tops. The figures are placed to the right of center and sharply cut by the frame. Degas' familiar use of two contrasting figures is here given compositional, as well as psychological, emphasis, and a dazzling use of several perspectives creates a peculiar tension. It seems that the artist had chosen to represent without comment a typical scene of two unconnected bohemian characters. *Absinthe* is not, as the outraged Puritans of the day pretended, a study in alcoholism but an Impressionist " slice of life," here drawn with extraordinary sensitivity and painted with a deft, incisive touch. It is amusing to compare Renoir's glamorous portrait of Ellen Andrée with Degas' pitiless and objective study. We may assume that the actress " dressed up " for this role as she would have done for some scene in the theater.

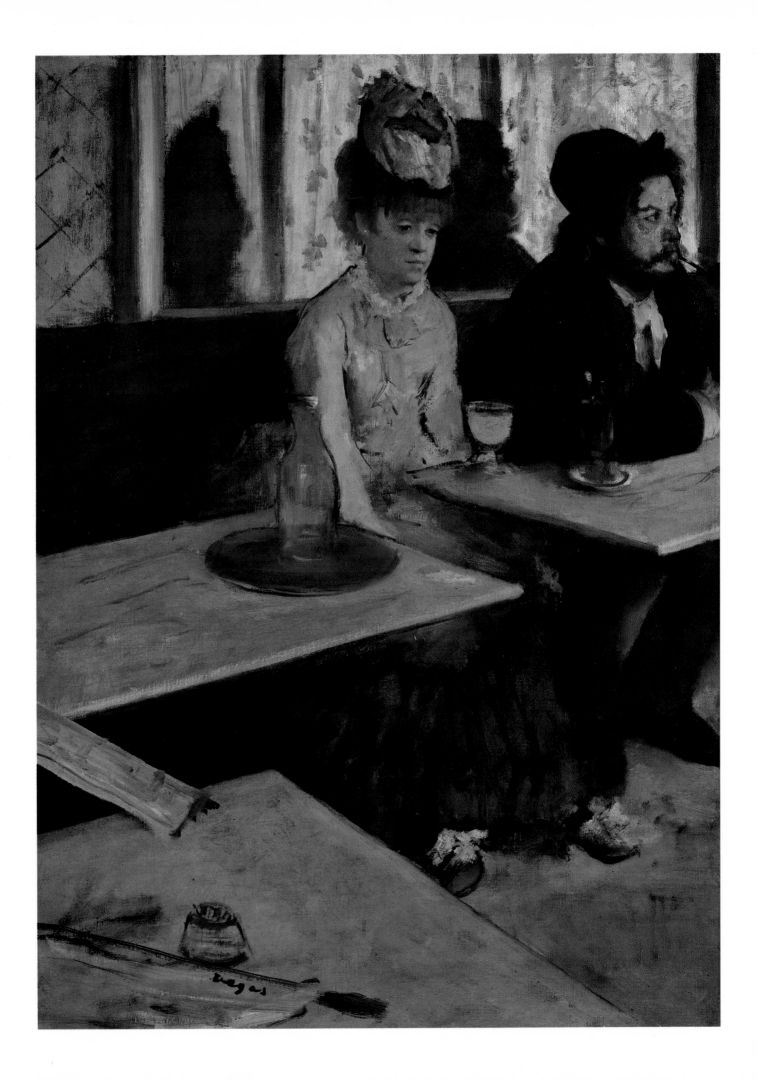

Painted 1876-1877

CAFÉ-CONCERT: AT LES AMBASSADEURS

Pastel on monotype on paper, $14\,^1/_2''\times10\,^5/_8''$

Musée des Beaux-Arts, Lyons, France

In many of his scenes of café life, Degas was struck by unexpected effects of light—the dazzling footlights, the softer illumination cast by gas globes against the evening sky, and the subdued reflections picked up by figures in the audience. It was a time of gay out-of-door entertainment in Paris and as the artist walked up and down the Champs Elysées, dropping in at some café and soaking in impressions, he was already planning such animated and complex pictures as this one. Later he would sketch from memory the figures on the stage, and gradually the idea would take shape until he finally put it down.

Here the picture began with a monotype in which Degas probably indicated the composition in a brownish black. Then he began to build up the color, accent the drawing, stress certain lights, darken other areas until the proper balance was achieved. The effect was to seem impromptu; the main figure, the singer, with her energetic gestures, is glimpsed over a foreground of apparently casual heads and hats, all however most carefully fitted into place and rhythmically tied together. Passing over the orchestra, where the top of a bass viol is silhouetted against the stage, the eye is focused strongly on the figures, brilliantly lit, and framed by the pillars behind them. In this small picture Degas has suggested a whole side of Paris life. It remains more than a typical Impressionist glimpse of an unusual subject; by its capital design and use of light and color the scene takes on a highly original and fantastic character.

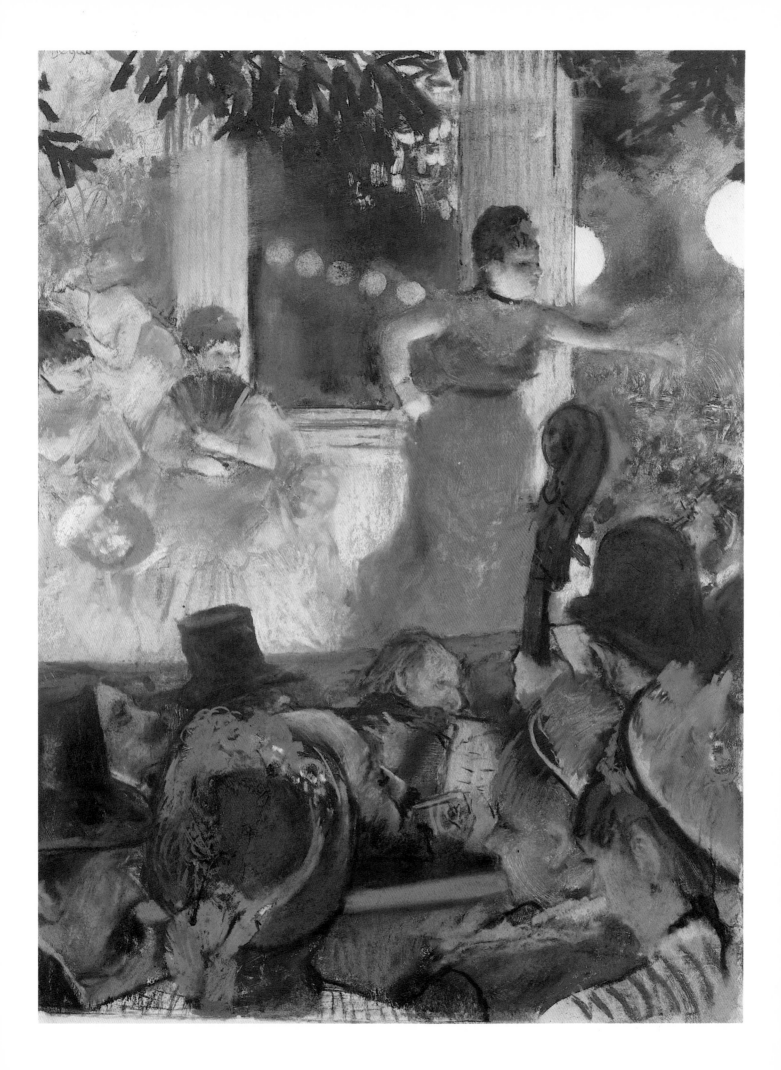

Painted 1876-1877

DANCERS AT THE BAR

Essence on green paper, 18 $^7/_8$″ × 24 $^3/_4$″

British Museum, London

A brilliantly conceived study for a famous painting in the Metropolitan Museum in New York. Like many of Degas' preliminary sketches it exists as a work of art in its own right, independent of the finished picture. As Degas matured, his brush drawing became more flexible and daring. Since he knew so well the movements of his ballet dancers, he could render them with a summary power which few artists of his period possessed. He was often led to contrast and compare two figures in action and here the two poses answer one another in an original manner. The dancer at the right is more fully painted; with a few broad, decisive strokes and a few high lights, she is given the solid form of a figure in the violent stretching exercise at the bar. Degas often worked on colored papers of this sort where the background gives a strongly decorative effect to the design and contrasts vividly with the few colors of the flat oil paint he employed. In the final painting the dancers are placed in the upper corner of the picture on a floor dappled with light and atmosphere. Degas was later dissatisfied with certain details of the finished painting and wished to retouch it but was forbidden to do so by its owner, his friend, Henri Rouart.

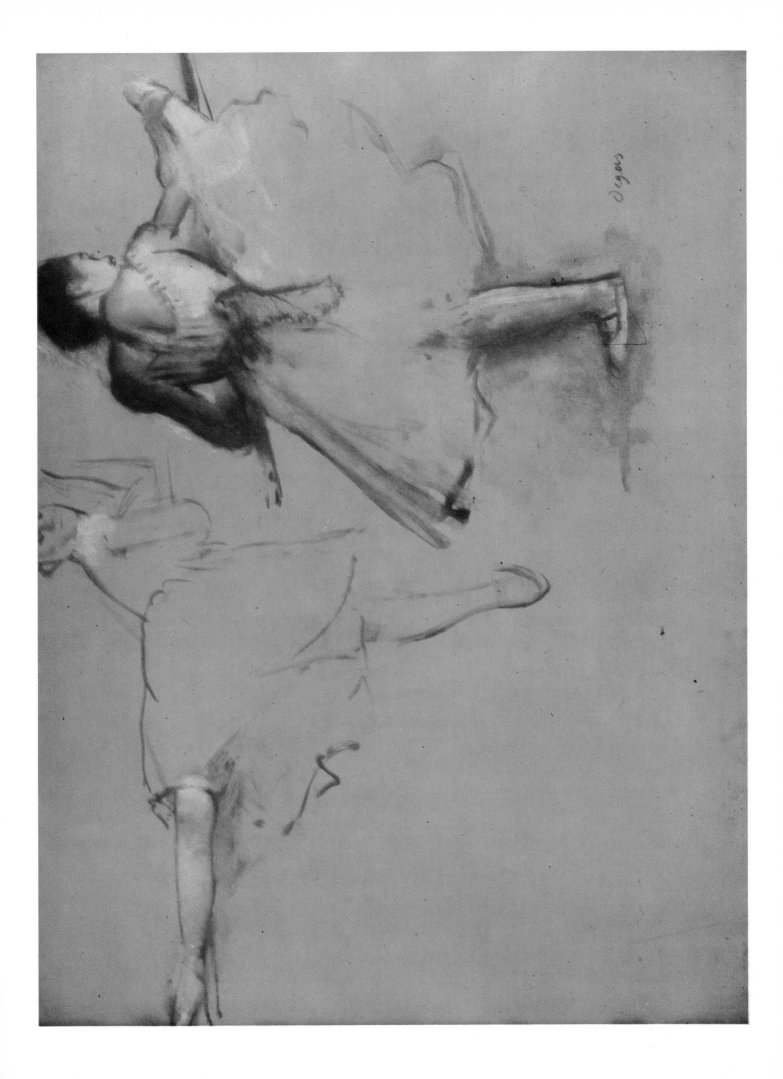

Painted 1877

WOMEN IN FRONT OF A CAFÉ

Pastel on monotype, $16^1/_8'' \times 23^5/_8''$

The Louvre, Paris

Degas loved the evening hour in Montmartre. As strong sunlight hurt his eyes he enjoyed wandering round Paris at night, picking up impressions, fixing indelibly on the plate of his memory certain scenes which he later developed with remarkable distinction in his studio. His method here was to start with the indications of the main forms of his picture painted on a metal plate. From this he took an impression on paper, building up the color and sense of detail in strokes of pastel.

This daring and angular composition with the pillars of the café sharply cutting the scene suggests the Impressionist search for sudden, fresh views of daily life. No one before Degas would have interrupted a figure with a vertical pillar stretching the entire height of the picture. No one else would have played so subtle a rhythm of curves, in the chairs, in the costumes, against these severe forms, or have studied the light of the interior as contrasted to the blurred, streaked night scene behind. As usual the poses and gestures are caught with a sharp eye; observe the woman with her fingernail held against her teeth in the center and the woman at the right leaning back and out of the frame. The color, with its muted harmonies and sudden sharp touches, helps to convey the evening mood. In addition Degas stressed the character of the moment; seldom sympathetic, except in portraits of his own class, he portrayed these women of the demimonde as somewhat ridiculous in their finery, managing to suggest a faintly sinister quality about the entire scene.

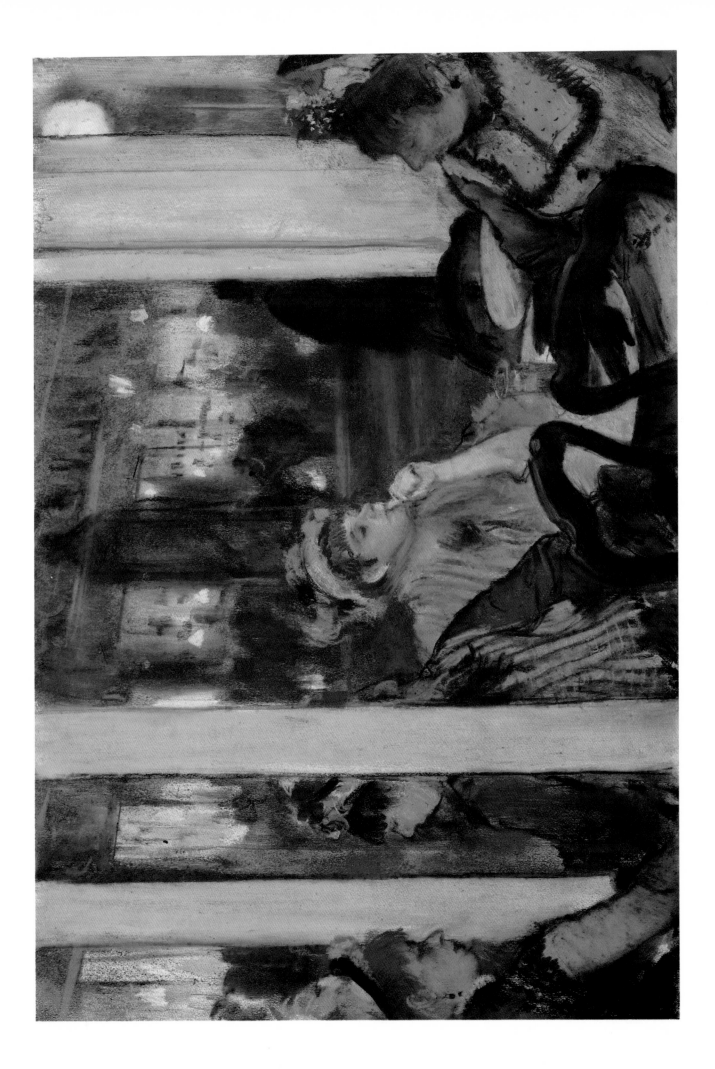

Painted about 1877

MLLE. MALO (?)

Oil on canvas, 31 $^7/_8$″ × 25 $^1/_2$″

National Gallery of Art, Washington, D.C. (Chester Dale Collection)

Degas did several paintings of this same woman, perhaps a Mlle. Malo, an un-important dancer of the Paris Opera. Compared to his earlier portraits where line and thinner color were stressed, this is unusually broad in its handling and rich in its resonant tone. The harmony of browns, blacks, and greens is relieved by the gold and silvery white of the flowers which seem a legacy from Oriental screen painting. They form an unusual burst of light behind the sitter's head, yet Degas has modeled the face so strongly that they do not compete with the portrait quality of the canvas but merely add to the effect. The features are interpreted with sympathy by the artist; one feels that Degas painted her not for her con-ventional beauty but because he found her interesting. Withal there is a certain mobility which gives the portrait that peculiar sense of life which Degas always stressed. Fascination, distinction—these are the qualities which the painter found in the personality before him. Though he returned to the same subject at least twice again, this is the most successful of the series.

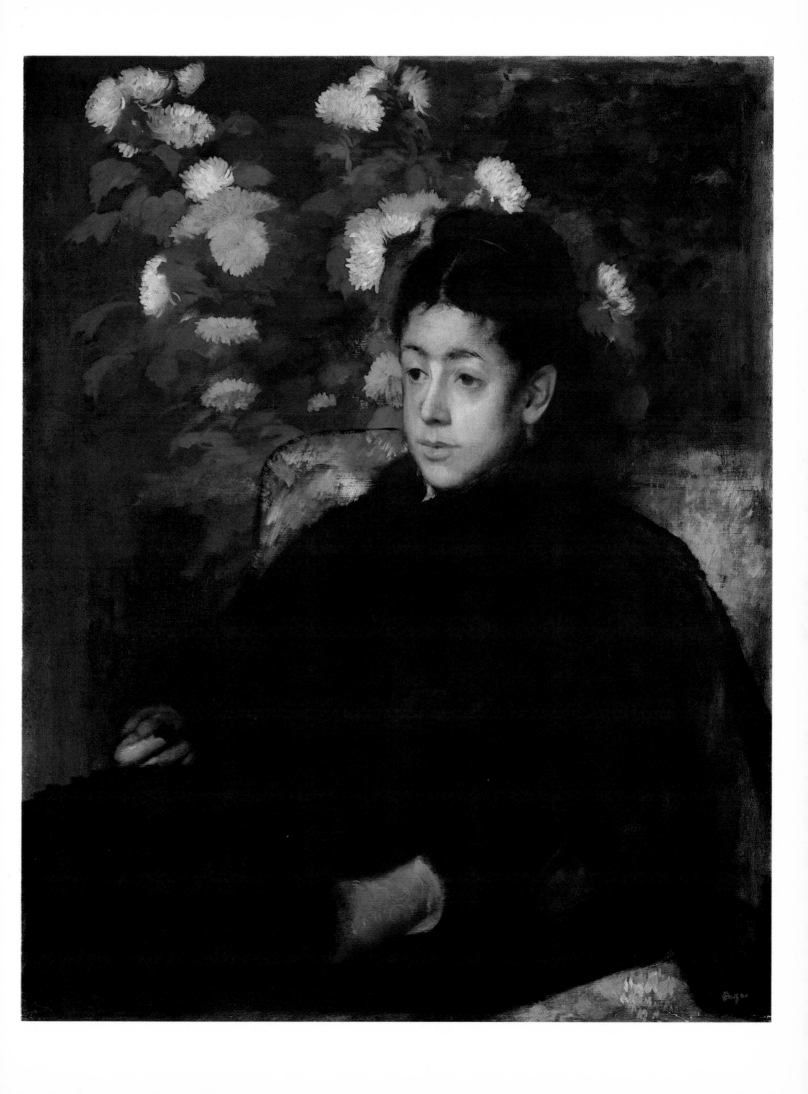

Painted about 1878-1879

REHEARSAL OF BALLET ON THE STAGE

Pastel on paper, 20 ¹/₂″ × 27 ⁷/₈″

The Metropolitan Museum of Art, New York
(The H.O. Havemeyer Collection. Gift of Horace Havemeyer, 1929)

Following the dancers out of their classroom to rehearsal on the stage, Degas was so fascinated by what he saw there that he made three similar attempts to fix the same moment. This is the best of the three, a witty comment on what goes on in the theater when the ballet is under preparation, with some dancers waiting in the wings, the director caught in the very midst of the action, other dancers in movement, and two bored men looking on from the side lines.

From an opera box the artist has found his plunging viewpoint which allows an abrupt unexpected foreshortening of the stage and its moving figures. The tempo is quick and animated; the arms and legs of the dancers are thrust out in sharp staccato rhythm, revolving in a concentric circle round the director, the spread-out skirt of the foreground dancer and the curving lines of the scenery contributing their part to this central movement. Striking, indeed, is the sharp observation of each figure: the yawning dancer, the gesticulations of the director, the inimitable poses of the men in the right distance. Yet with all its psychological comment the picture is more than a mere illustration of stage life. Degas has studied the effects of light upon his composition, contrasting the radiance of the footlights with the shadows of the empty stage in the background. He has invented a contrast of dark forms, like the curve of a bass viol and the dark suit of the director, with the light gauzy skirts of his dancers and the forms of the painted scenery. He has shed charming colors of pinks and rose and grays and gray-whites, touched here and there by small accents which bring the scene to life and supply further action throughout. Everywhere is the mark of his rhythmic drawing which in pastel, more than in oil, is apparent in quick, masterful strokes.

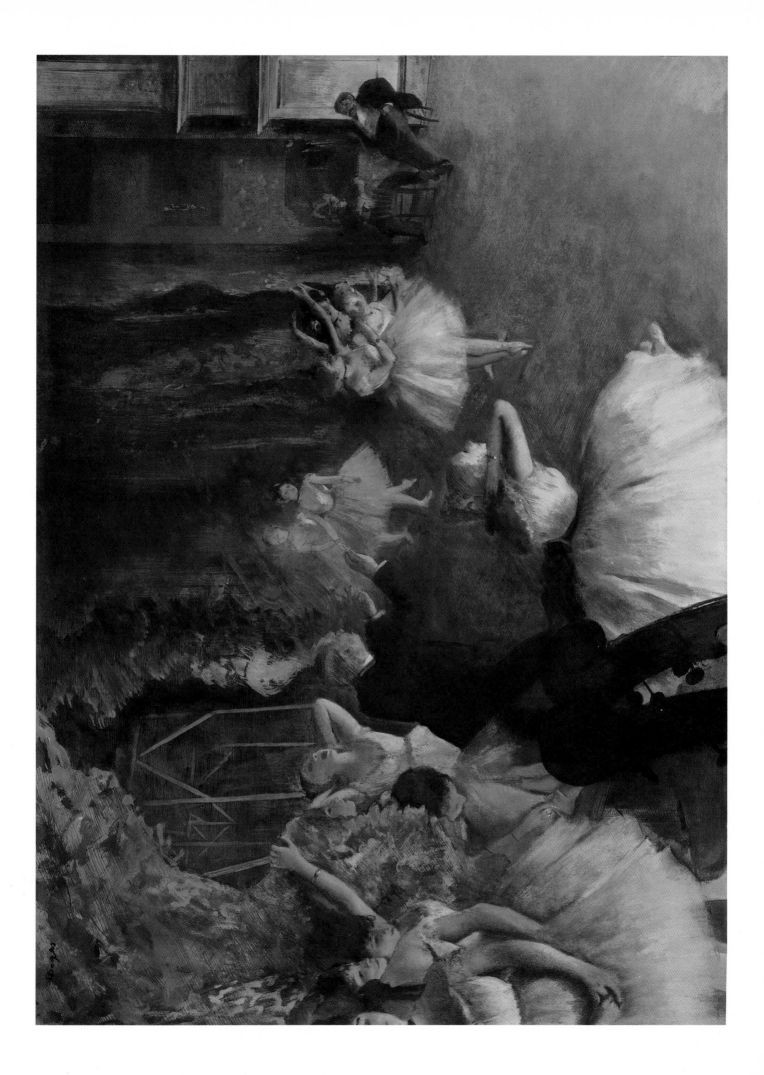

Painted 1879

DIEGO MARTELLI

Oil on canvas, 43 $^1/_4''$ × 39 $^3/_8''$

National Galleries of Scotland, Edinburgh

Though Degas painted fewer and fewer portraits as he grew older, some of his later work in this genre ranks among his greatest achievements. There is a strength, a warmth in them which seldom emerged in his more restrained earlier canvases. Diego Martelli was a Neapolitan engraver who worked in Paris, and the artist liked to drop into his studio and speak Italian with him. He did this delightful portrait as a testimony of this friendship, conveying the homely ease and clutter in which Martelli worked.

The viewpoint was consciously adopted to stress the rotund body of the sitter. From his pictures of the stage Degas had learned the value of different eye levels to add variety to the usual frontal view. This device allowed Degas as well to flatten out the table top and create an interesting pattern of the scattered papers and objects of the engraver's art—a passage which is contrasted with the simple broad lines of the figure set opposite it. The blue of the table cover is carried into the blue sofa behind and the sweeping curve of the sofa's back carries the eye round to the figure of Martelli. The warm grays, pinks, and russet tones, the occasional flash of yellow and red are carefully balanced. Throughout, the brushwork is broad and sensitive and shows the effect of Degas' interest in pastel: the paint is stroked and lightly applied here and there in a manner which suggests crayon, rather than pigment. Dissatisfied with this format, Degas tried a second portrait of Martelli, fitting the figure into a horizontal, rather than a vertical, canvas. Such variations were typical with Degas who was continually striving to capture the exact placing and mood of his models.

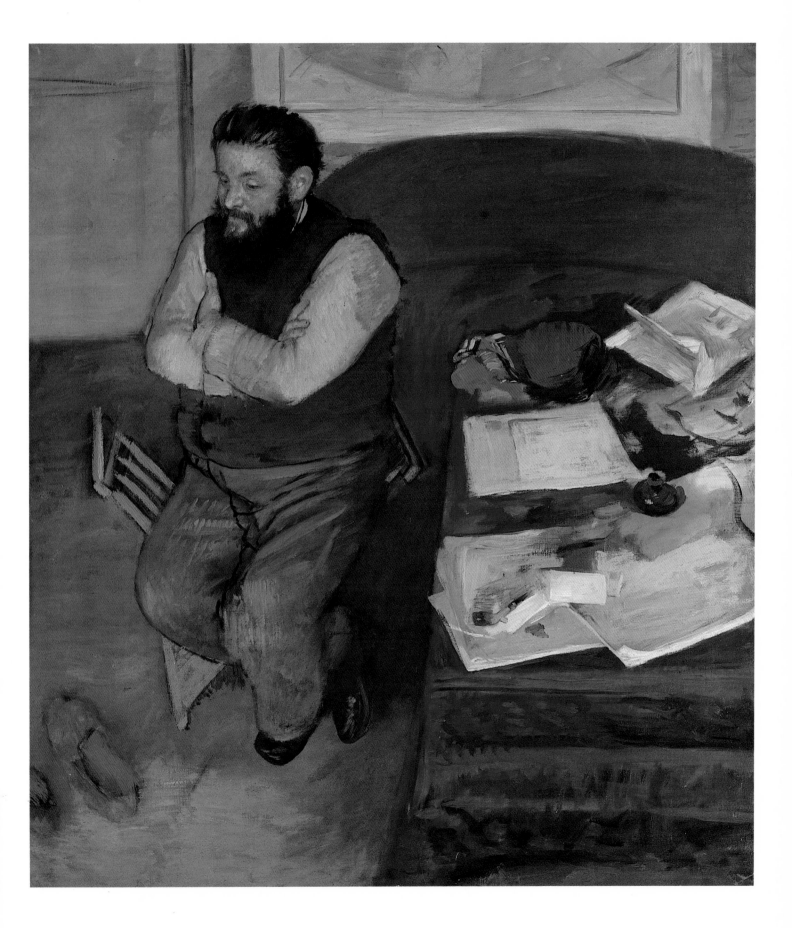

Painted 1880

THE DANCING CLASS

Pastel on paper, 24³/₄″ × 18⁷/₈″

Denver Art Museum, Colorado

Degas did not picture the ballet only in its floating, ecstatic moments. His trenchant eye observed, with a devastating realism, the moments of preparation in the classroom and the actions of the dancers, adjusting their slippers, stretching their muscles, trying out their steps. He revealed the awkwardness, the physical conditioning of the performers, finding a new beauty in such truth.

This is a typical snapshot view of a number of seemingly unrelated actions fitted into a design. The four figures are pushed into the right side of the picture—the two dancers, with their contrasted poses, are linked by the overlapping of their ballet skirts and by the two outsiders, perhaps their mothers, who seem engaged in conversation. The artist sought out such contrasts—the young girls with their light, gauzy costumes, against the dark street clothes of the older women, and between the women themselves a further difference of age and perhaps social status, suggested by the bonnet and shawl of the one and the plumed hat of the other.

Movement is conveyed by the standing dancer who seems about to move out of the picture, and by the strong diagonals of the floor and slanting bench and wall which converge in the opposite direction. So just is Degas' feeling for light that the scene is bathed in a clear, revealing atmosphere, the exquisite grays and whites of the ballet costumes brought to life by sudden and unexpected touches of color here and there.

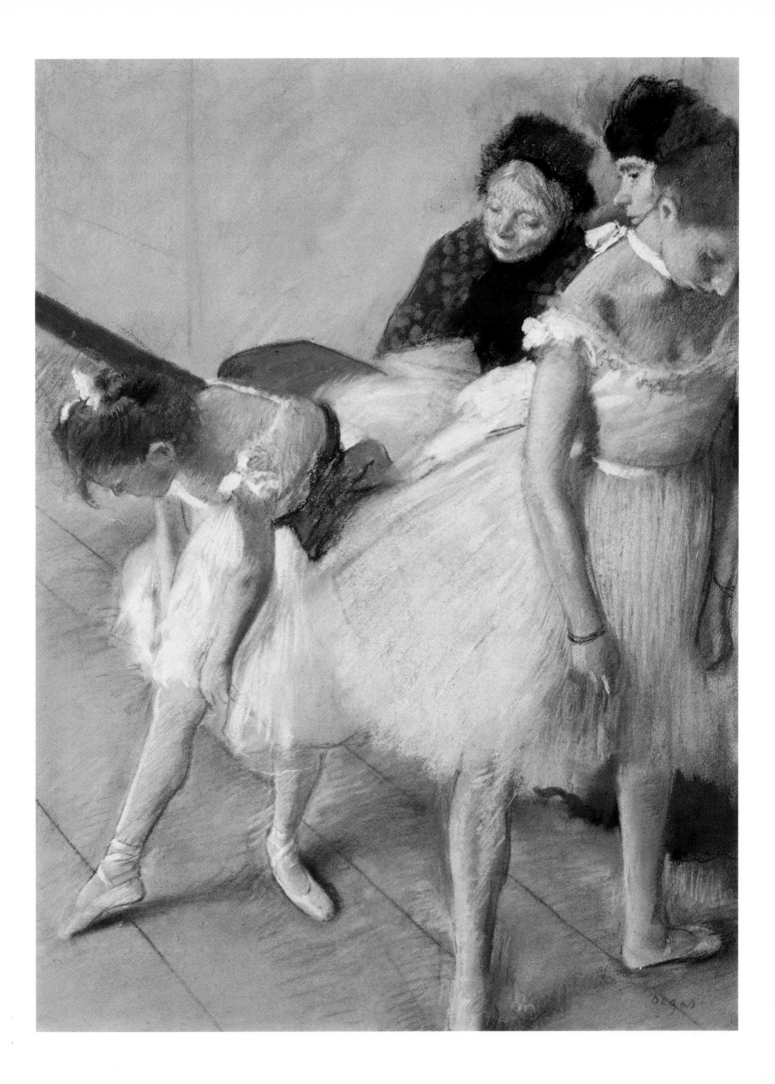

Painted about 1880

ON THE STAGE

Pastel on paper, 22″ × 15 ³/₄″

The Art Institute of Chicago (Potter Palmer Collection)

In painting the ballet usually Degas did not reproduce exact moments from actual performances. Rather his way was to synthesize and to suggest a mood. Though the dancers might first be studied alone, then combined in groups, the effect was to convey the whirling movement, the spontaneous play of gesture under the dazzling or mysterious light of the stage.

This work is done in the lightest, softest, most nacreous color which perfectly suited the artist's use of pastel. The tilting dark of the foreground, the zone of light beyond, the blurred background of the stage-setting create a space into which dancers in two groups are skillfully and daringly balanced. Those in distance turn away from the spectator; those in front move quickly to the lower right, cut by the frame, while a characteristic movement, starting in the angular foot and leg of the figure at the bottom, is caught up and conveyed through the whole composition. The only developed figure is the one in the right center, the rest being indicated only in part. Lest the color become too anemic, Degas has accented it with dark notes and little shreds of stronger color which glint in the artificial illumination.

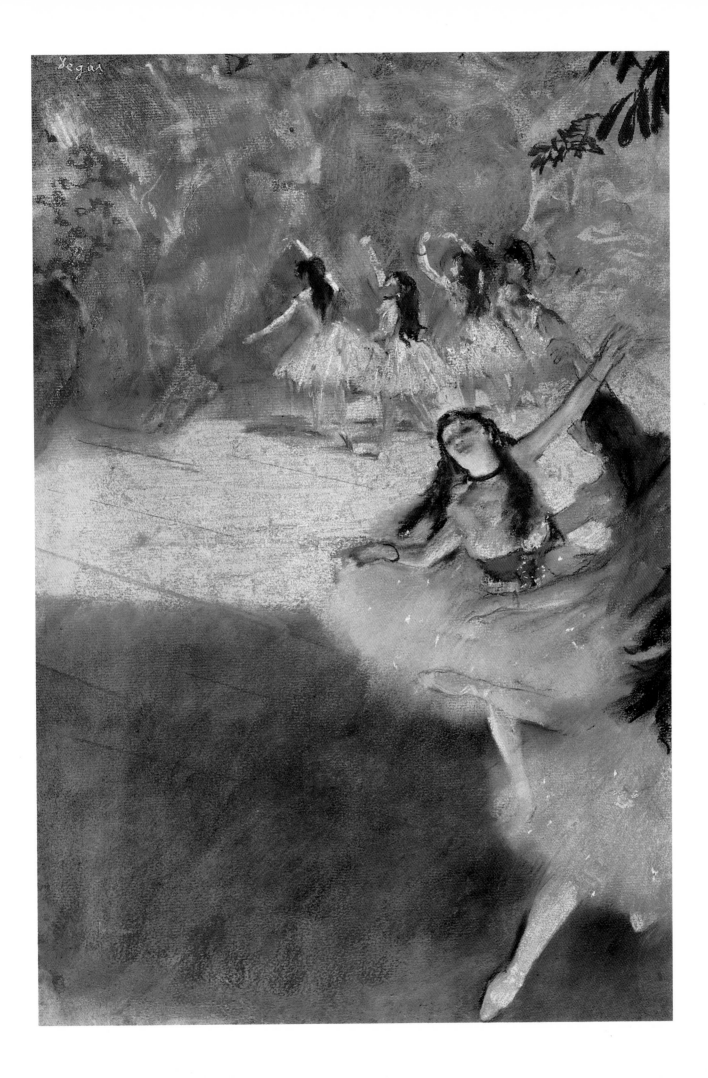

Painted about 1881-1885

JOCKEYS

Oil on canvas, $10\,^1/_4''\times 15\,^3/_8''$

Yale University Art Gallery, New Haven

As he advanced, the artist sought to convey his meanings by developing a fragment, rather than completing a whole composition in detail. Compared with earlier *Jockeys*, this daringly designed picture is full of just that sort of surprise attack which Degas loved. Instead of seeing the horses and their riders at the post, we are suddenly thrust in among them as though the spectator were himself on horseback. This is the close-up, long before that form was invented in the motion pictures. Only Degas would have made the right-hand side of his picture out of two enormous heads of horses and suggested space by the diminishing size of the jockeys in the center.

Movement is strongly to the left, and the broad energetic drawing, with its emphasis on silhouette, is balanced by the use of primary colors in the jackets: red, yellow, and blue. By this time Degas was replacing the Impressionist technique of color spots and broken reflections of light, with a heavier, more sculpturesque treatment. This is a picture of energy; horses and riders moving in a slow, rhythmic procession, close together, almost jostling one another. The pose of the jockey on the left is wonderfully caught, Degas enjoying the sinewy strength of the body under its gay apparel.

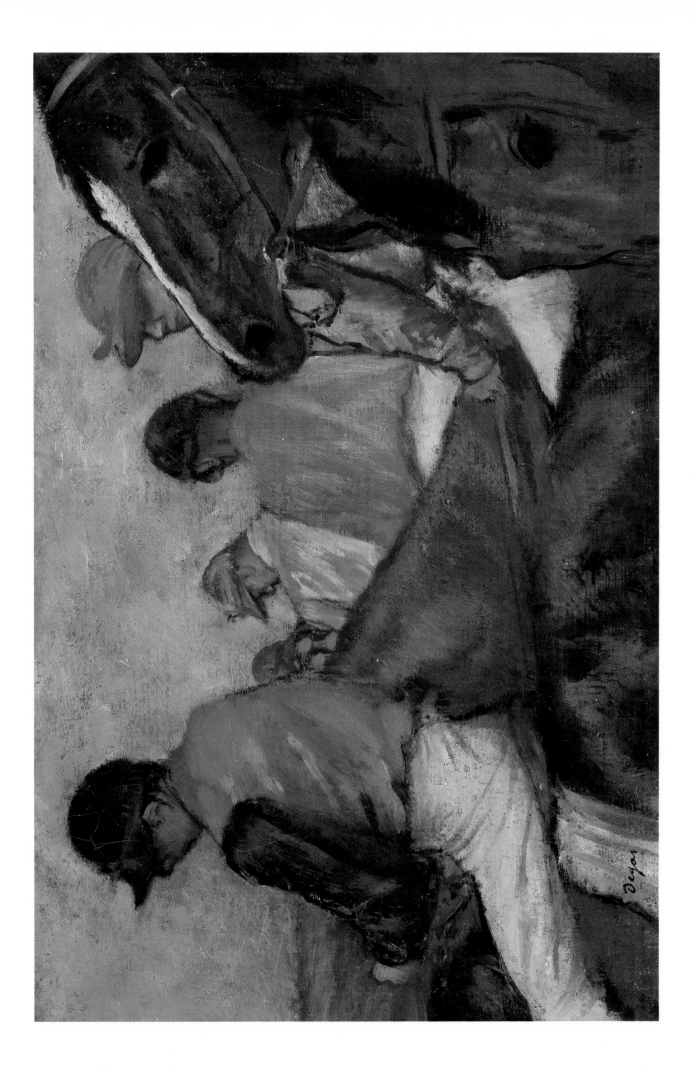

Painted about 1882

WAITING

Pastel on paper, 18 ¹/₂″ × 23 ⁵/₈″

Norton Simon Museum, Pasadena, and J. Paul Getty Museum, Malibu

Waiting is another example of Degas' originality in composing two figures into an arresting design. It is also another case of the story-telling picture without a story. A dancer in ballet costume and a woman in street dress are waiting, perhaps in the anteroom of the Opera. The woman draws aimless patterns with her umbrella on the parquet floor. The girl bends over, massaging her left ankle with her hand. With these simple means and by suggesting a blankness of space through the suppression of all detail, the artist has created an almost endless moment of boredom.

The composition is contrived to emphasize the mood. The weary, bending form of the dancer is opposed to the patient, more erect and yet slumping figure of the woman. Both figures are on the left side of the bench, the diagonal line of which is paralleled in the floor boards, and again emptiness on one side is balanced by fullness on the other. The round, curving lines of the girl are played against the angular outline of the woman, the charm of color in her costume against the snuffy black of her companion's.

As Degas went further with pastel, he used it more frankly, allowing the strokes to show, using its sketchy lines to build a detail, or, as here, supply strong accents which give the figures solidity and character.

Painted 1883

BREAKFAST AFTER THE BATH

Pastel on paper, 47⁵/₈″ × 36¹/₄″

S. Niarchos Collection

This is one of the earliest complete statements of a theme which was to occupy Degas for the rest of his life. More and more he began to study the female nude, not in the way the old masters had, discreetly in some historical or mythological setting, but frankly for itself. This was the new realism in painting, divorced from the idyllic settings of a Corot or the heavy forest backgrounds of Courbet. All of Degas' respect for classical tradition found its expression in pictures of this sort. He added a note that was new, that of observing, strongly and passionately, woman in her bedroom, in her bath, engaged in all the simple, expressive tasks of combing her hair, toweling herself, twisting, bending, and turning in those energetic actions which bring out the structure of the body and its play of muscle and flesh.

Here the artist chose to develop a moment, stressing the energetic movement of the nude woman with her moving, agitated arabesque of form, pitting it against the calm, column-like figure of the servant, connecting the two with the curves of the tub. The naked body is strongly modeled in color, and Degas shows how much he depended on the Impressionist method of turning light into brilliant hues, building through green shadows and violet and pink highlights a solid form, which in turn catches and reflects the glowing colors of the room, and weaves throughout a harmony rich and unusual in its combinations. In certain areas patterns of one color are laid over another; the technique is one of pastel built up in solid masses, streaked and retouched again and again for dramatic emphasis of color and drawing.

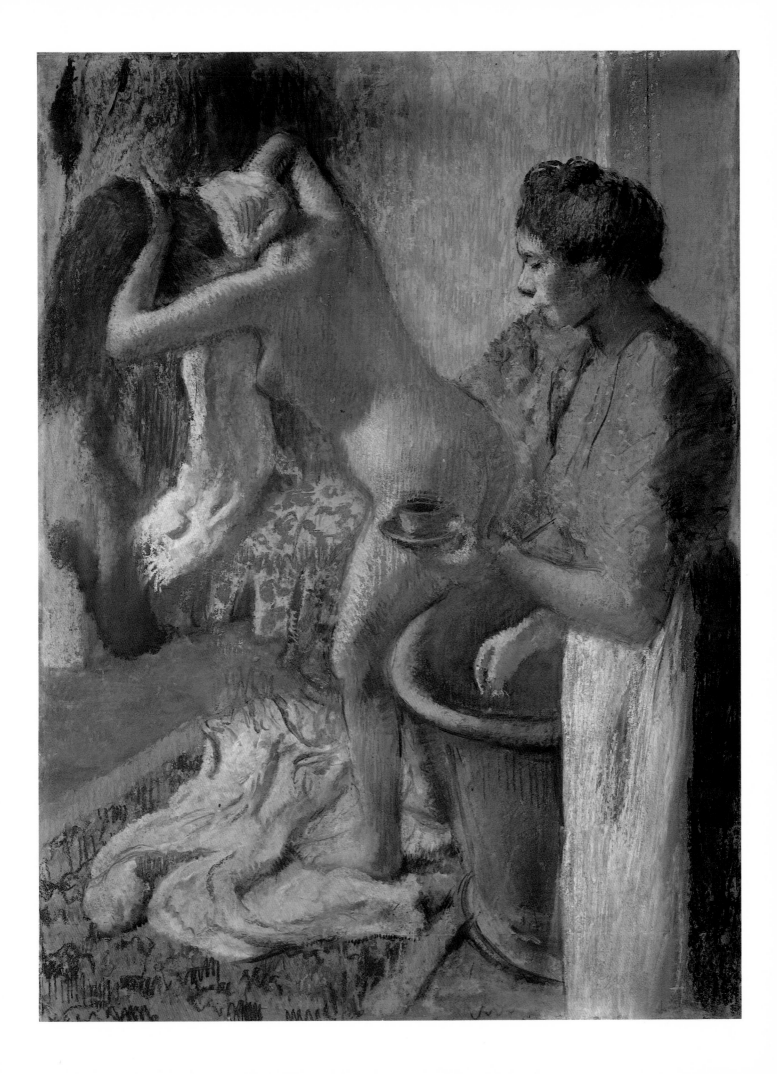

Painted about 1884

TWO LAUNDRESSES

Oil on canvas, 29 ⁷/₈″ × 32 ¹/₄″

The Louvre, Paris

This composition of two laundresses is a rich study of character and counter-movement. Again, a composition with two figures in differing action; the artist has dared to represent one figure stretching and with her mouth open in a yawn, and the other pressing down on her iron in a pose which brings every muscle into play. Subjects like this had been taboo in painting until the Impressionists; and among them Degas was perhaps unique in finding an almost classical form to express so homely a scene from everyday life. In this way he parallels the interest of a writer like Zola who was widening the subject matter of the novel much as Degas was broadening the field of art.

The composition is as remarkable as the sympathetic, even subhumorous comment which the artist makes on his models. The table which cuts diagonally across the foreground like his tilting stages and flattened floors, bringing us into the picture; the strongly felt contours of the figures themselves with their rhythm of contrasted curves and angles; the unusual palette and sense of light which permeates the entire scene—all these are unified into a design of such strength and power that one thinks almost of some classical relief, strangely and effectively turned into a comment on modern life.

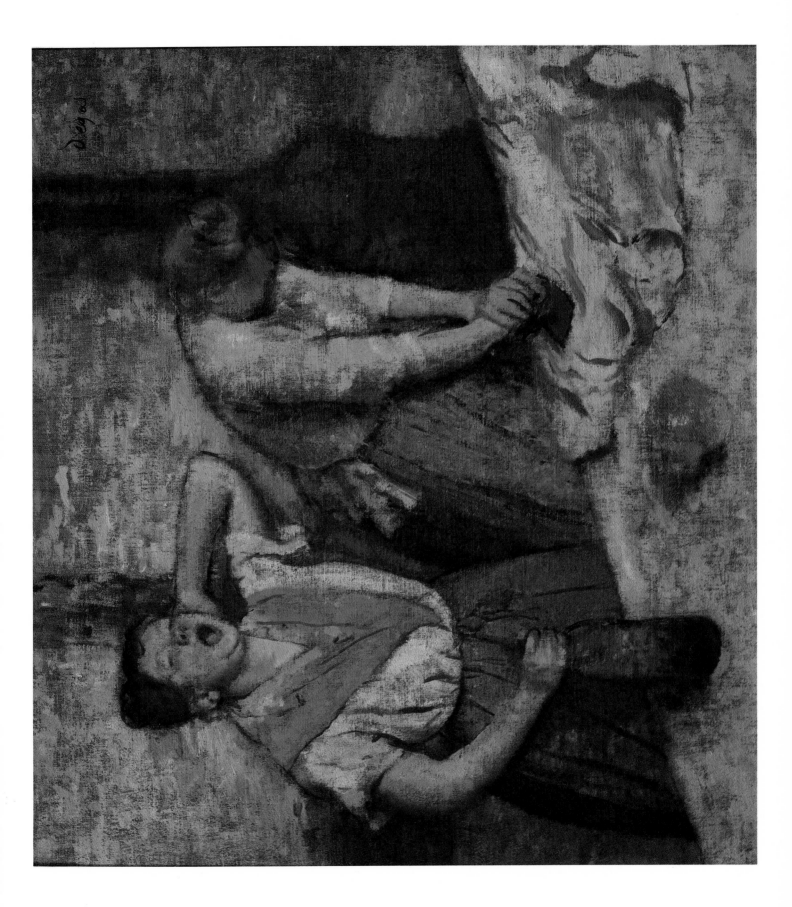

Painted 1885

BALLERINA AND LADY WITH A FAN

Pastel on paper, 26″ × 20″

John G. Johnson Collection, Philadelphia Museum of Art

To surprise an effect was often Degas' idea. His variety of treatments of the ballet is enormous and none is more original than a series of scenes on the stage, glimpsed from an opera box, where space between spectator and dancer is telescoped and we feel thrust suddenly into the very midst of a performance. The theme of the dancer, caught in a characteristic moment, is also found in one of Degas' best sonnets:

> She dances, dying. As around the reed
> Of a flute where the sad wind of Weber plays,
> The ribbon of her steps twists and knots,
> Her body sinks and falls in the movement of a bird.
>
> The violins sing. Fresh from the blue of the water
> Silvana comes, and carefully ruffles and preens:
> The happiness of rebirth and love on her cheeks,
> In her eyes, on her breasts, on her whole new being. . .
>
> And her satin feet like needles embroider
> Patterns of pleasure. The springing girl
> Wears out my poor eyes, straining to follow her.
>
> With a trifle, as always, the beautiful mystery ends.
> She bends back her legs too far in a leap,
> It's the leap of a frog in the Cytherean pond.
>
> *(translated by Bertha Ten Eyck James)*

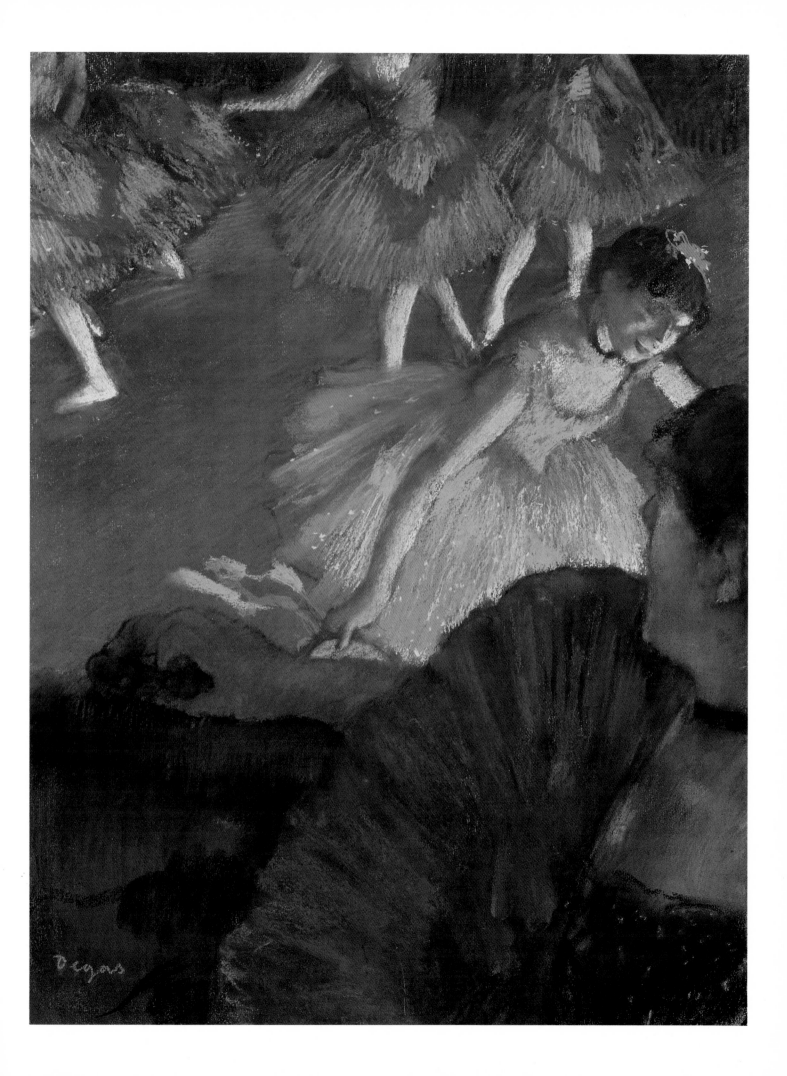

Painted about 1885

THE MILLINERY SHOP

Oil on canvas, 38⁷/₈″ × 42⁷/₈″

The Art Institute of Chicago (Mr. and Mrs. Lewis L. Coburn Memorial Collection)

Degas painted no still lifes. The flow and movement of life interested him far more than inanimate objects; he sought, above all, the human figure in its infinite variety of gesture and action. Even here, when he concentrates on a table of hats in the shop of a fashionable modiste, he plans his picture round a person.

The design is abrupt and surprising in its angular arrangement of the table top and the figure of the modiste who holds up a hat in her stockinged hand. The round form of the hats is contrasted with this straight-line arrangement; and in the deft, exquisite touch with which he has treated these frivolous objects, there is a reminder of the way he painted skirts and costumes of his ballet dancers. Their range of delicate colors is further compared with the golden orange of the table top, the blue background of distance, and the neutral green of the woman's dress. Throughout there is a soft pervading glow of color, a richness of light and texture, a breadth of painting which shows that Degas carried over from pastel to pigment many of the discoveries he had made in his use of crayon on paper. There is a further unstressed variance between the simple garb of the modiste, with her piquant profile, and the luxurious and fashionable hats which surround her.

Such paintings grew out of many visits to the houses of fashionable dress-makers in the company of Mme. Straus, a devoted friend of the artist. One day, noting his concentration at a fitting, she inquired what could possibly interest him. " The red hands of the little girl who holds the pins," he replied gravely.

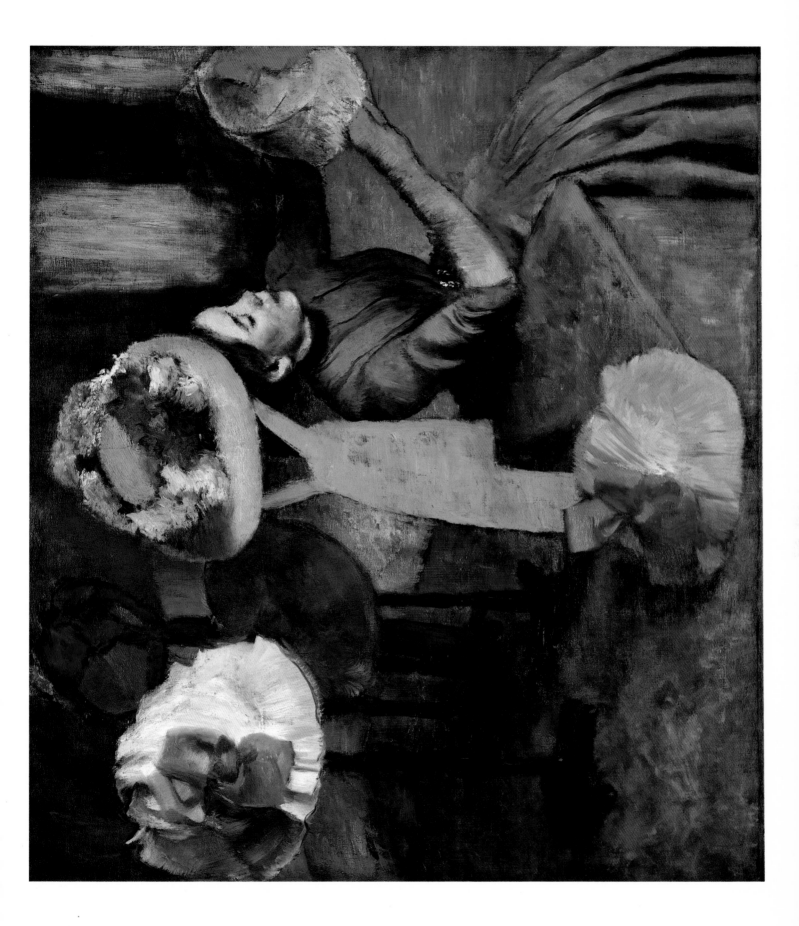

Painted 1886

THE TUB

Pastel on cardboard, 23 ⁵/₈″ × 32 ⁵/₈″

The Louvre, Paris

This is one of the artist's most original variations on his theme of a woman at the bath. Where the classical artist of the past had used such a subject in a more formal way, often suggesting the goddess in the feminine form, Degas was more objective, more truthful, as he studied his model in every unconscious pose. This somewhat shocked the Paris of the eighties; ablutions were thought to be more a matter for the boudoir than the art gallery. But it was Degas' ability to combine narrow observation from nature with a sense of extraordinary drawing and composition, so that in the end Paris forgave him.

Probably from Japanese art was derived this daring perspective with its tilted point of view and the shelf of toilet articles which runs in a flattened vertical to contrast with the curves in the figure and the round tin bathtub. Over his bed Degas hung a scene of women in a bathhouse by the Japanese master of color prints, Kiyonaga, and it may well be from such a source that he conceived his first idea. But always the realist, Degas has made something extremely solid as well as lovely in surface from the figure of the woman. The rhythm of the body's contour is most delicately apprehended and the way the light falls is skillfully observed to model the full, rounded forms, which, incidentally, are echoed in the pitchers on the shelf. Supple, masterly, sketchy here, more finished there, is Degas' use of pastel. Never before or since has an artist found such a range in this medium. To compare another solution of the subject, see the following picture of the bath done at the same time.

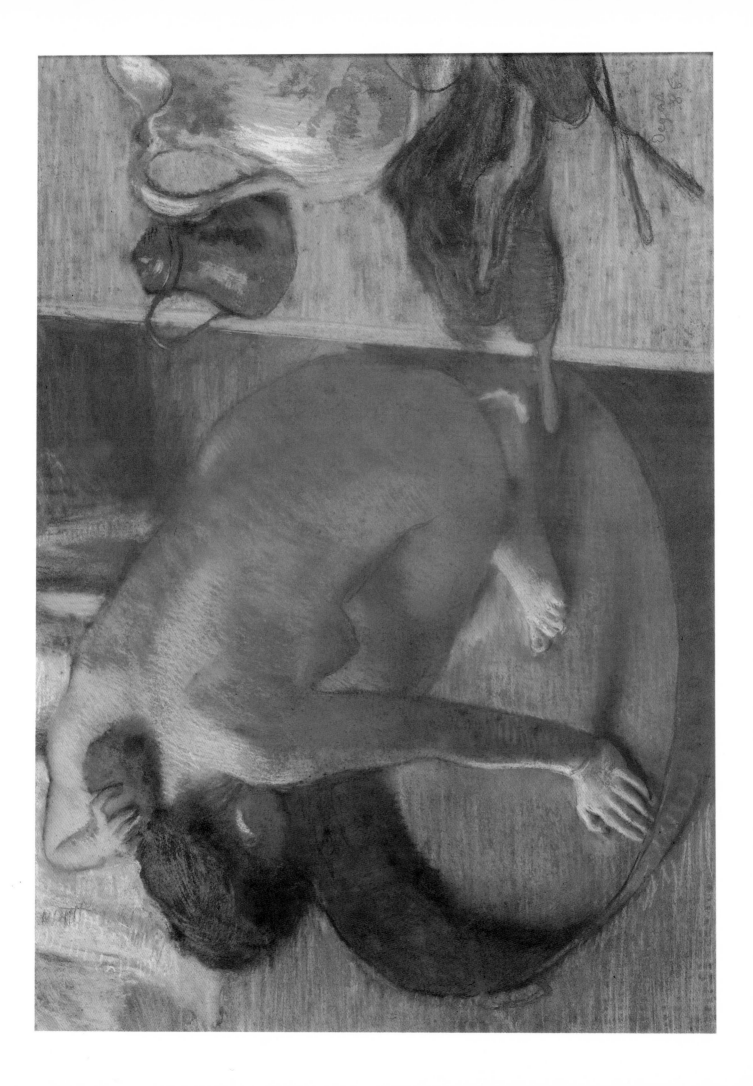

Painted 1886

THE TUB

Pastel on paper, 27 $^1/_2$" × 27 $^1/_2$"

The Hill-Stead Museum, Farmington, Connecticut

Degas never surrendered a subject until he had tried it from every available point of view. When he returned to his theme of a woman taking a bath in a round tin tub he made something entirely different each time. He had the ability to see freshly over and over again.

These women, whom he studied so assiduously in the intimate confines of their boudoirs, do not exist as individuals. He seldom personified them; their faces are often hidden by the poses he caught them in; usually there is only a line of cheek, an ear, a slight indication of profile. The artist concentrated instead on the supple or tensed bodies and rendered, by his powerful drawing, the play of muscles beneath their light-struck flesh. There is something curiously chaste about his reaction; his nudes are never voluptuous and they lack the healthy animalism of Rubens or the radiant sensuality of Renoir. They are first and foremost studies of the human form and only secondarily women.

This brilliant example shows Degas depicting the figure with considerable realism. Whenever he began a new series on a single theme it was his way to suggest a wealth of detail. Remarkable is the seeming awkwardness of the pose, an awkwardness redeemed by the extraordinary composition with its repetition of the curved lines of the tub, the head and back. The strong action of the bent figure, with the arm grasping the sponge and continuing in a series of arcs up the right side of the body, is played against the angular folds of the drapery and the jutting thrust of the left arm. Modeled in rare and unusual color which unites with the glancing light to set the figure in space, it is one of Degas' most vigorous treatments of the nude.

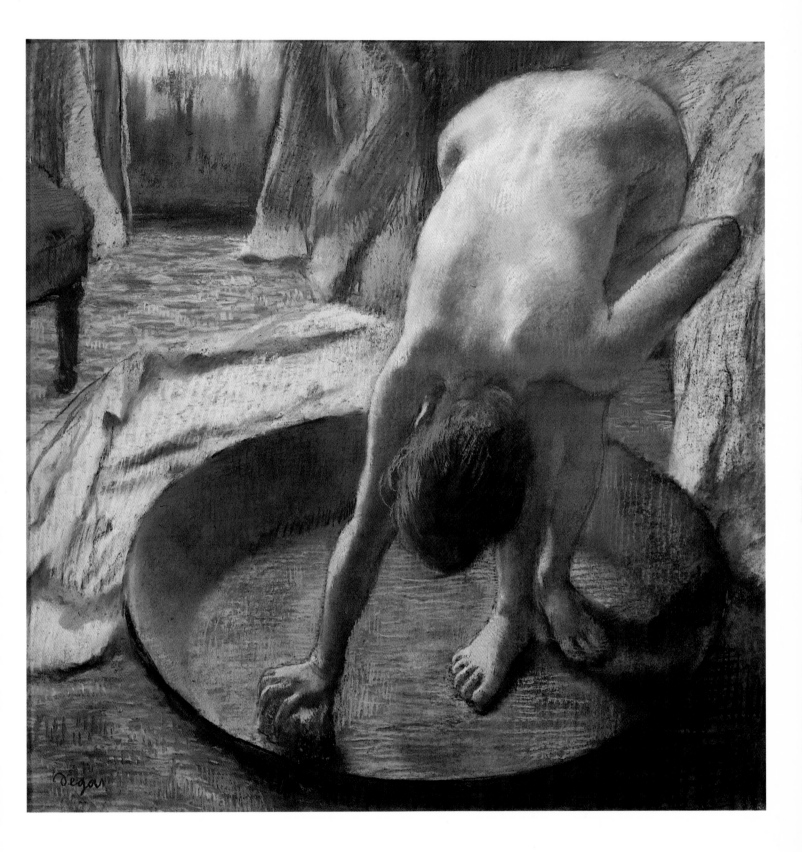

Painted about 1889

THE MANTE FAMILY

Pastel on paper, 35 ³/₈″ × 19 ⁵/₈″

Philadelphia Museum of Art

In this delightful picture of a family group in the ballet Degas has combined elements of portraiture with types drawn from his backstage experience. How often he must have seen the mothers of the little ballerinas fastening ribbons in their hair or tying bows on their shoulders! Here he has contrasted the child in her dancing costume with the slightly older sister in street clothes, a contrast which is subtly felt in the poses of the two girls, the one on the left stolid and waiting, the *danseuse* already stretching her toe and more fluid and graceful in the whole line of her figure.

This pastel is unusually sober in color for Degas. Rather than his unusual mixture of bright and brilliant hues, this is a harmony of blacks and browns and russets, against which the light tones of the ballet costume stand forth. As usual the drawing is vivid and searching, the parallel strokes of pastel building the form and giving a unifying sense of texture to the whole picture. The Mantes were notably connected with the Opera in Paris; the father a bassoonist in the orchestra and the three daughters at one time or another dancers in the ballet. The one in the practice costume is Suzanne, then about seven years of age. Her sister, Blanche, is in street clothes and was eight or nine at the time.

Painted about 1890

THE MORNING BATH

Pastel on paper, 27 1/2" × 16 7/8"

The Art Institute of Chicago (Potter Palmer Collection)

As he progressed with drawing and painting nudes in interiors, the artist caught them in more and more active moments, leaping in and out of the tub or twisting in strange and distorted positions. Here the angle of vision is abrupt, and movement is rendered not only by the figure but by the strong zigzag of line starting in the lower right edge of the picture and carrying back through the tub and the glimpse of the wall.

The foreground, with its subtle transformation of white bedclothes into scintillant blues and grays, is contrasted with the zones of rich patterns in the curtains and walls behind. The figure diagonals into deeper space and is treated in a summary, broad manner, the painter strengthening certain lines and blurring others to suggest a sense of interrupted action. By this time Degas had freed himself from the bonds of realism; his drawing is powerful and abbreviated and his forms exist less as an impression of nature than for the part they play in his organized design. The brilliance of the blues and greens forces the warm tones of the flesh and throughout the artist seizes upon cross reflections of light, playing one light upon another rendered through dots and strokes of vivid color. Such unusual harmonies may be in part derived from his studies of Oriental art, particularly from rugs and textiles which he collected enthusiastically during this period.

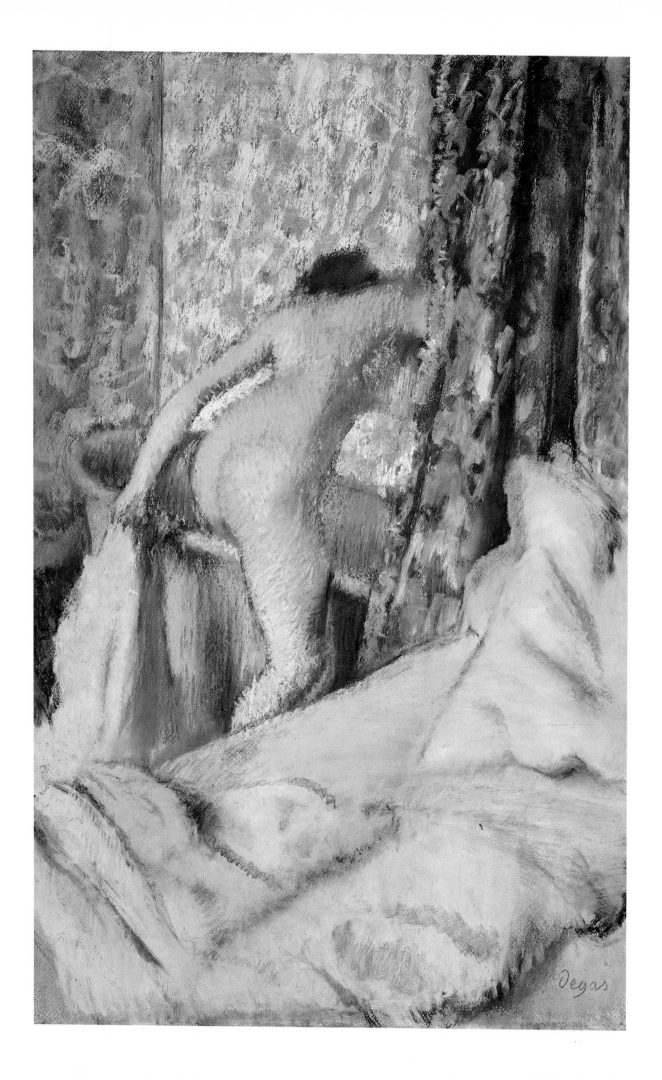

Painted 1899

DANCERS

Pastel on paper, 24" × 25¹/₈"

Toledo Museum of Art, Ohio (Gift of Edward Drummond Libbey)

This late pastel of the ballet shows Degas returning to a theme which occupied him often during his later years—a close-up of a group of dancers, waiting in the wings, touching their costumes, a moment of relaxation between active moments of the dance. As a matter of fact, the older Degas grew, the less likely was he to attempt the more violent action of the ballet on the stage. He went seldom to the theater and his dancing pictures became more set as he studied individual models in his studio. Perhaps it was this quality that lay behind the testy exclamation of Zola, " I cannot accept a man who shuts himself up all his life to draw a ballet girl as ranking co-equal in dignity and power with Flaubert, Daudet, and Goncourt."

As a matter of fact Degas had long left off any attempt at realism in the sense Zola admired and practiced it. In such a pastel as this he expressed, rather than described, the curious and unexpected effects of color and light backstage, strongly, vividly studying the way various hues played on one another, exaggerating reflections, drawing his figures broadly, striping and overlaying his pastel to gain new effects of texture. The result is a strengthening of the Impressionist broken color and at the same time a new fantasy and unreality in the treatment of the theater and its dancers.

122

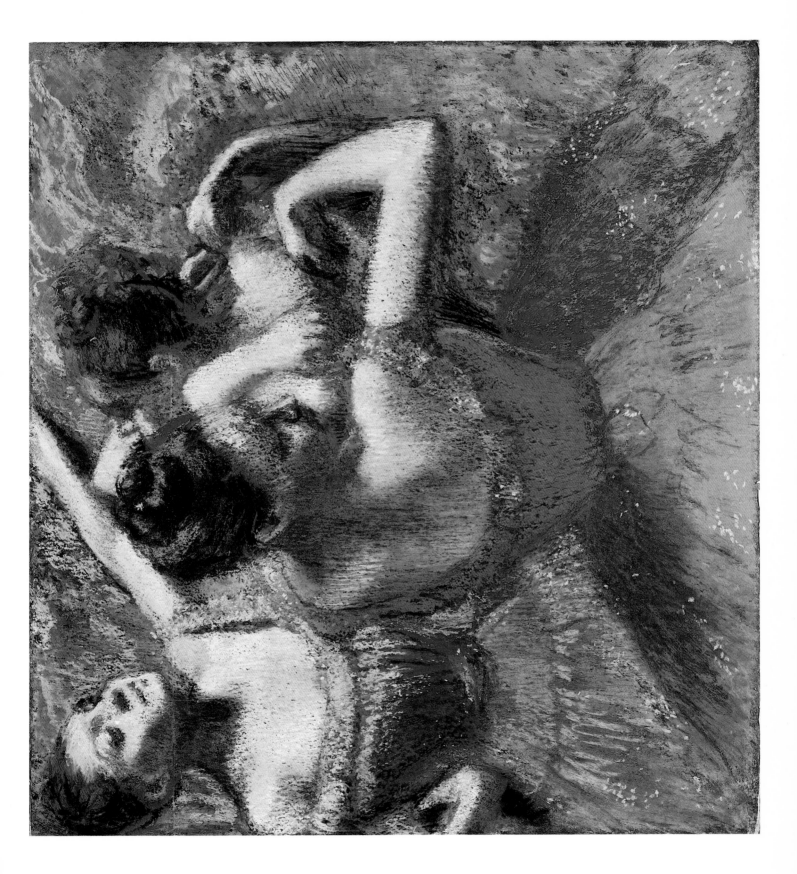

Painted about 1903

WOMAN DRYING HERSELF

Pastel on paper, 27¹|₂″ × 28³|₄″

The Art Institute of Chicago (Mr. and Mrs. Martin A. Ryerson Collection)

Many variations on this theme were attempted by Degas, none stronger, bolder, or more violent in color than this late example. The picture exists in a brilliant, Expressionist glow which reaches its climax in the red hair of the bather, against a brilliant fiery orange patch in the background. No longer do we distinguish wall or drapery. Space is flattened into a pattern of vivid hues, scratched and crossed by other colors laid over them. In places the pastel is several coats thick, Degas allowing glints of the undercolor to show through. There is no attempt to study actual reflections; rather he weaves an unreal pattern of color as a background for his figure.

The action of the woman is now strongly simplified and only those elements are kept which convey the dominant movement of the body. Charcoal is boldly used for outlines, and many colors, put on in excited strokes of rose, pale green, and lavender, give the figure a strange prismatic force. In such works Degas seems to belong more and more to the twentieth century. Though still based on a study from nature, such a pastel is strongly abstract in feeling, foretelling by some ten years the experiments of Kandinsky and the German Expressionists who will finally do away with all references to the object, liberating light and color and line, and allowing them to become the new basis of painting.

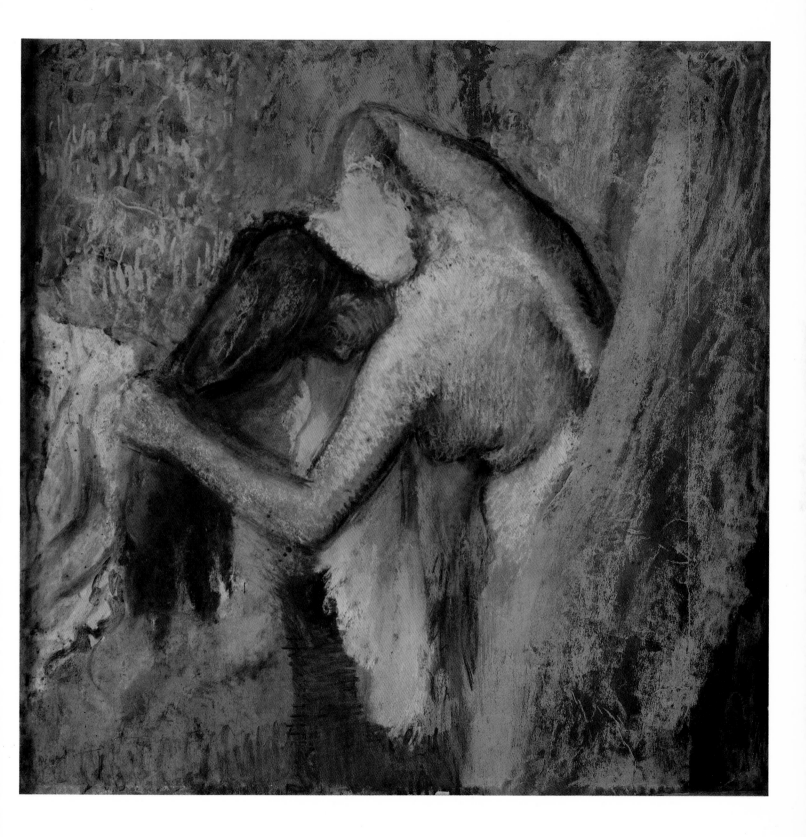

Painted about 1903

FOUR DANCERS

Pastel on paper, 33" × 28³/₄"

Private Collection

Many of Degas' late works in pastel are more *painted* than drawn. He now used coat after coat of colored chalk, moistening them and piling up one surface on another until these works take on something of the quality of miniature frescoes. No longer are outlines and contours stressed; Degas goes back to the deep, sonorous colors of the Venetians, rather than to the Florentine draftsmen whom he earlier loved.

Such a pastel with its rich, brooding color expresses a new, passionate feeling in the artist. Nothing is more surprising than this final burst of romantic force in a man who coolly spent most of his life in a search for classical perfection. As he intensified his composition, as he bent and dissected his drawing and heaped up crushed, jewel-like color upon color, Degas became, at the end of his career, a modern artist who through his Expressionism influenced both Bonnard and Rouault and many of the more creative colorists of our own day.

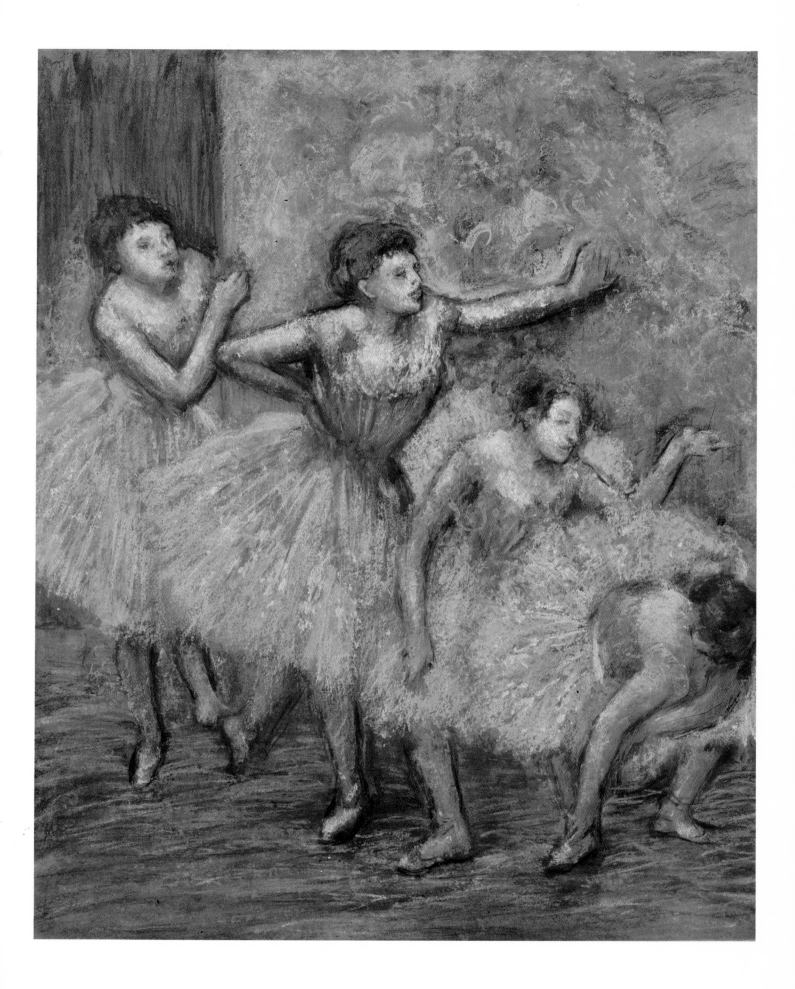